THE INVENTION OF

PAINTING IN AMERICA

THE LEONARD HASTINGS SCHOFF MEMORIAL LECTURES

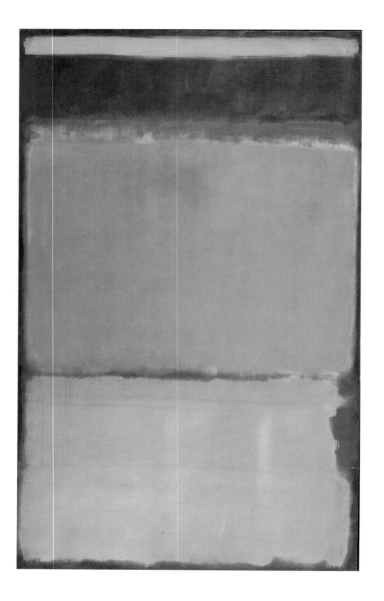

DAVID ROSAND

THE INVENTION OF
PAINTING IN AMERICA

NEW YORK COLUMBIA UNIVERSITY PRESS

Chapter openers include details from the following works: facing chapter 1, from fig. 3, Matthew Pratt, *The American School*; facing chapter 2, from fig. 8, Thomas Cole, *The Oxbow (View from Mt. Holyoke, Northampton, Mass., After a Thunderstorm)*; facing chapter 3, from fig. 80, Thomas Hart Benton, *Louisiana Rice Fields*; facing chapter 4, from fig. 93, Jackson Pollock, *Number 1A, 1984*. Full source credits appear with figure captions

 Columbia University Press

Publishers Since 1893

New York Chichester, West Sussex

Copyright © 2004 David Rosand

Library of Congress Cataloging-in-Publication Data

Rosand David

The invention of painting in America / David Rosand.

p. cm. — (University seminars/Leonard Hastings Schoff memorial lectures)

Includes bibliographical references and index.

ISBN 0–231–13296–4 (alk. paper)

1. Painting, American. 2. Abstract expressionism—United States.

I. Title. II. Series.

ND205.R67 2004

759.13'09—dc22 2004047829

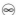

Columbia University Press books are printed on permanent and durable acid-free paper.

Printed in the United States of America

Designed by Linda Secondari

c 10 9 8 7 6 5 4 3 2 1

Over in Europe they had art for years. Over here they hadn't.

—Stuart Davis

I feel sometimes an American artist must feel, like a baseball player or something—a member of a team writing American history.

—Willem de Kooning

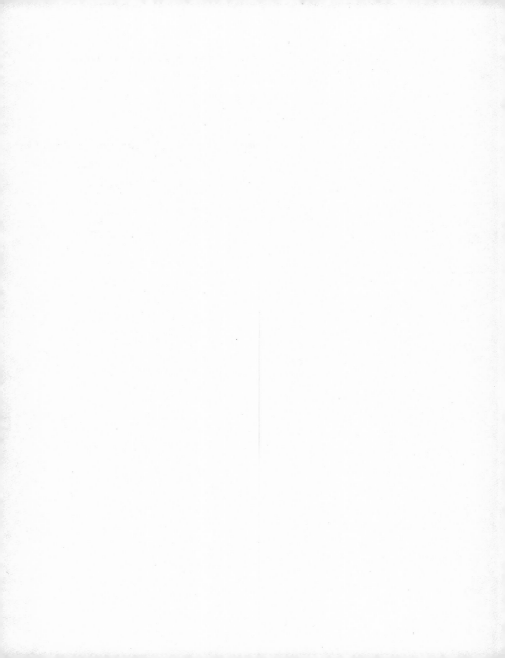

UNIVERSITY SEMINARS
Leonard Hastings Schoff Memorial Lectures

The University Seminars at Columbia University sponsor an annual series of lectures, with the support of the Leonard Hastings Schoff and Suzanne Levick Schoff Memorial Fund. A member of the Columbia faculty is invited to deliver before a general audience three lectures on a topic of his or her choosing. Columbia University Press publishes the lectures.

DAVID CANNADINE
The Rise and Fall of Class in Britain 1993

CHARLES LARMORE
The Romantic Legacy 1994

SASKIA SASSEN
Sovereignty Transformed: States and the New Transnational Actors 1995

ROBERT POLLACK
The Faith of Biology and the Biology of Faith: Order, Meaning, and Free Will in Modern Medical Science 2000

IRA KATZNELSON
Desolation and Enlightenment: Political Knowledge After the Holocaust, Totalitarianism, and Total War 2003

LISA ANDERSON
Pursuing Truth, Exercising Power: Social Science and Public Policy in the Twenty-first Century 2003

PARTHA CHATTERJEE
The Politics of the Governed: Reflections on Popular Politics in Most of the World 2004

CONTENTS

ILLUSTRATIONS

ACKNOWLEDGMENTS

The invitation to deliver the tenth annual Leonard Hastings Schoff Memorial Lectures at Columbia University in 2002 was particularly welcome, for it offered the opportunity to return to a subject that has occupied me in various ways for many years. I am most grateful to Robert Belknap, Director of the University Seminars at Columbia, for the invitation and that opportunity.

These lectures have their origins in much earlier endeavors on my part to achieve some kind of coherent vision of the history of American painting. The challenge to deal with that history was afforded by my colleague Barbara Novak, who had developed a pioneering, and very popular, course at Barnard College on the subject: "American Art from Colonial Times to the Armory Show" (Art History 77).

When she went on sabbatical leave in 1965 I was asked to teach that course—it was not easy to find an art historian then who had much background or interest in American art, and I had some of the former and more of the latter. Abandoning my Renaissance studies for a while, I immersed myself in Americana, seeking to extend my view of the field beyond an immediate engagement with recent American painting—Abstract Expressionism, in particular—back to its colonial origins. My version of the course, like the Schoff Lectures, was founded on a thesis I tested in a brief article—overly ambitious, perhaps even irresponsibly so—"Style and the Puritan Aesthetic: The Search for Tradition in American Art (continued)," published in a short-lived periodical, *Art Voices* (1966). Since that foray into her class on American painting and my subsequent return to that syllabus, Barbara has continued to be both mentor and companion in the field. My own education in American art has been served by my role as reader on many of the dissertations she has supervised at Columbia, and so it is indeed fitting that I add my own appreciation to the list of graduates she thanks in the preface to her *Nature and Culture: American Landscape Painting, 1825–1875* (1980).

In teaching Art History 77 I had another important companion and guide, John McCoubrey, not personally, but through his intelligently conceived anthology of sources and documents, *American Art, 1700–1960* (1965), which, published just in time, served as a basic text for my teaching. His own little book, bravely titled *American Tradition in Painting* (1963), had already inspired me as a student, for it raised essential issues about painting in America and elevated the discourse above the antiquarian level that had seemed to define so much of the scholarship in the field to higher standards of critical insight. John too was evidently inspired by the experience of Abstract

Expressionism and seemed to be looking back on the history of American painting from the vantage of its success. In both books, he found the right voice.

An invitation from Dore Ashton to deliver a lecture in 1989 in the Critique Series at the Cooper Union for the Advancement of Science and Art led me to formulate some of my ideas on "The Artist in the Work." Beyond her encouraging hospitality on that occasion and in our continuing relationship, Dore in her own work has set a model of engaged historical criticism; in particular, *The New York School: A Cultural Reckoning* (1972) stands as an important contribution to what I would call the studio history of art, the kind that embeds art in history without ever forgetting that it is made by artists.

Such was certainly the attitude of my greatest mentor in the field, the late Meyer Schapiro. His generous response to art, of both past and present, was for me, as for so many others, the exemplary model of profoundly engaged criticism. To him I owe my personal involvement with artists of the generation that established the dominance of painting in America. Indeed, he was the first art historian whose name I had ever heard, for it was sounded in both cultural and political contexts in leftist households of my youth.

Which brings me to the more personal roots of my involvement with American painting: My earliest introduction to that art had come from my father, an artist himself, who taught me to regard the watercolors of Winslow Homer with special reverence: *there* was technique and natural control of the brush. A committed socialist, my father followed the events of the 1930s with partisan involvement, and his copy of the published proceedings of the *First American Artists' Congress* of 1936 introduced me to the issues that had so engaged him. His subscriptions to *American Artist* and *Art News* pro-

vided me with an education in the range of pictorial possibilities, the one offering technical models of fine illustration, the other inviting—indeed, daring—a young artist to join a more modern adventure. Throughout my youth, I attended Saturday morning art classes at the Brooklyn Museum, where I studied painting with Isaac Soyer, whose brother Raphael occasionally covered for him; my contact with the traditions of socially conscious realism was thus direct.

Eventually, however, *Art News* trumped *American Artist*. As an aspiring art student in the 1950s, I was overwhelmed by the phenomenon of Abstract Expressionism. I suspect it was the big brush of de Kooning's canvases of 1957–1958 in particular that, by its sheer power, intimidated me and encouraged my eventual turn to art history and criticism. My growing fascination with the painting of the Abstract Expressionists—let alone my frustrated attempt to emulate it—left my father perplexed, but his constant questioning of my taste did force me to try to formulate a more articulate apology for such aesthetic apostasy. I believe he would have appreciated my effort to come to terms with the art he so valued, and I dedicate these lectures to his memory.

We find that the question,—What is Art? Leads us directly to another,—Who is the artist? and the solution of this is the key to the history of Art.

—Ralph Waldo Emerson[*]

FOREWORD

The first general history of Abstract Expressionism, published more than thirty years ago, declared it the "Triumph of American Painting."[1] As we look back across over half a century to that triumphant epoch, the late 1940s and 1950s, with the retrospective vision of art history, the ambiguity of that title becomes ever more resonant. Read one way, it can seem aesthetically rather parochial: a celebration of the final, long-awaited, maturity of painting in America. Sounded in another, more chauvinistic key, it trumpets success on a global scale, indeed, imperial: the assumption of American leadership of art in the West—a role accompanying its political and economic position following the Second World War, artistic confirmation of Henry Luce's proclamation of the twentieth as the "American Century."[2]

The international impact of Abstract Expressionism—especially as this American art was exhibited around the world as the manifestation of American virtue, the fruit of individual freedom of expression—has provoked a certain ideologically inspired skepticism in some subsequent accounts, which credit its success to the joint effort, if not conspiracy, of the Museum of Modern Art and the United States Information Service to promote this avant-garde art.[3] The triumphal attitude to which this revisionist alternative reacted had been founded on an essentially formalist critical view, one that saw this achievement in a rather Hegelian light, celebrating it as the inevitable realization of qualities inherent in the materials of painting itself.[4] Although my own sympathies may lie closer to this latter view, this is not for its teleologic but for its aesthetic focus, because it explicitly acknowledges both the art and its making—and, therefore, its maker.[5]

The success of American painting can hardly be dismissed as aesthetic imperialism, a weapon of the Cold War; rather, it was the achievement of a generation of artists confronting the possibilities of the art of painting in this country and responding to its challenges. Rejecting the thematic clichés of Americana, they confronted the received formal lessons of European modernism without benefit of a firmly established tradition of their own. Lacking such confident foundation, they had to rediscover the art of painting for themselves.

The achievement of American painting following the war does indeed appear as a triumph—of American painting and of painting in America. It is a triumph defined by the longer history of the art in this country and must be measured against that history. These lectures, then, reach backward from the generation of Jackson Pollock to the colonial art of John Singleton Copley; they are offered as pro-

legomena to a proper study of Abstract Expressionism. My thesis is that this achievement, the quite varied art of a generation of painters in New York toward 1950, is, in a precise sense, rooted in the historical situation of painting in America, that the conditions that determined the position of the art in this country also provided the crucible for new aesthetic energies. The very difficulty that painting had in finding full cultural acceptance in America, the suspect status of the artist, the ingenuousness of aesthetic attitudes that could not acknowledge the independent reality of art—these conditions, paradoxically,[5] proved fertile ground for the growth of painting in this land, enabling its eventual triumph.

My primary concern is less with the parochial question of "what is American about American art" than with a pictorial manifestation of what has been identified as "a central aspect of our Puritan legacy, the rhetoric of identity."[6] At issue are the identity of the artist and of the work of art, the personal investment of the artist in his work and the recognition of his presence in it. I believe that there are certain basic values that informed and inspired the production of painting in this country throughout most of its history. What I shall call a puritan aesthetic could be seen as an oxymoron, a simultaneous susceptibility to and corollary suspicion of pictorial illusion, a faith in pictorial fiction and a fundamental mistrust of the reality of the picture plane as a worked surface. In such tension painting in America, paradoxically, found a positive creative potential. Like his viewers, the painter in America confronted the picture plane and the colors applied to it with a sense of moral righteousness. The mark of the artist, the stroke of his brush, was not to intrude between the beholder and the proper object of attention, the subject depicted. Style and technique, the operational foundations of the art, are

superficial and not to be trusted. Nor is the imagination, that ultimate source of deceit, which, too, betrays reality. Working within and against a culture of such attitudes, each of America's strongest and most individual painters—Copley, Eakins, Homer, Inness, among them—forged his own art.

In the middle of the nineteenth century Asher Brown Durand intuited a basic dilemma confronting the painter in America when he wrote that "the most important thing is to find *what to paint*— the *how to paint it* will come in due time."[7] What and how to paint: from Copley's search for subjects nobler than his colonial sitters and a style appropriate to such ambition, through the celebration of Thomas Cole's landscape paintings as "acts of religion," to Stuart Davis's modernist commitment to the American scene, those issues remained critical.

It was through their realization that the two could not be separated that, a century after Durand, a group of painters resolved the dilemma and achieved the "triumph" of American painting. In that dialectical resolution and in their individual responses to the challenge, those painters—who were eventually to be labeled Abstract Expressionists—discovered that the proper subject of the modern artist was indeed the artist, that it was only by exploring the expressive potential of his own activity that something new was possible: an art that manifested to the highest degree "the presence of the individual, his spontaneity and the concreteness of his procedure."[8] And this involved the radical reinvention of the art of painting.

THE INVENTION OF

PAINTING IN AMERICA

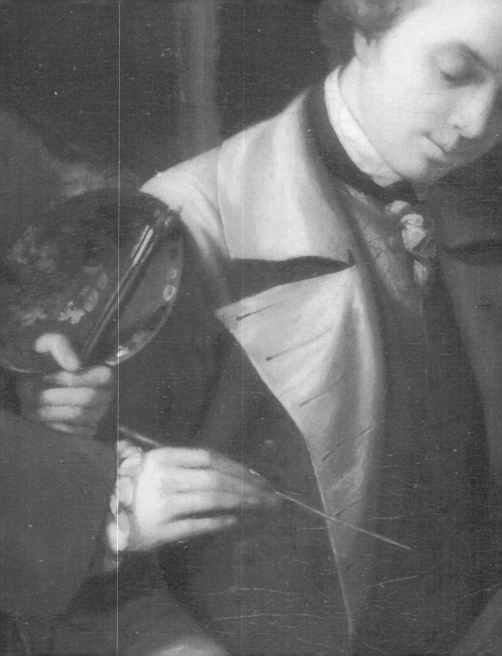

See quick approach, that time of renown,
When painting, also with promethean fire,
Shall deck her canvas, and her forms attire;
When architecture shall erect the dome,
Whose fame shall rival that of ancient Rome;
When music's hand shall strike the silver lyre,
And marble, grace, from sculpture's skill acquire.
Then shall Columbia's artists seek no more
For foreign smiles upon a foreign shore;
But here combine together, to display
The finish'd glories of her risen day.

John Swanick, "Poem on the Prospect of Seeing the
Fine Arts Flourish in America" (1787)[*]

ONE *Declarations of Independence*

America's artistic "time of renown" was not to arrive for another cen-
tury and a half, its "risen day" accompanying the emergence of the
nation as the leading world power in the wake of World War II. A
tense relationship with European tradition had characterized the
situation of art in America from the very beginning, dooming it
apparently to perpetual provincial status. "Over in Europe they had
art for years," as Stuart Davis (1894–1964) observed. "Over here they
hadn't."[1]

The situation seemed finally to have been resolved through a
reversal. History had conspired to cripple the creative energies of
Europe. A generation of American artists, however, had been spared
the immediate ravages of war. Nurtured in the 1930s, coming to

artistic maturity in the course of the forties, they were beneficiaries of geographic distance from the front and, a cultural consequence of the war, of the presence in New York of emigré artists from Europe. By the end of the war they were ready to demonstrate to the world the aesthetic independence that had been the goal of artists in America for so long: realizing a new art to accompany the new republic—an aspiration that had found such grandiloquent expression in John Swanick's poem. Their moment of arrival did indeed represent a "triumph" of painting in America.

At last, it seemed, American painting had achieved independence, nearly two centuries after the political declaration. During those intervening years the measure of American aesthetic achievement in the visual arts had been, inevitably, a European standard. From the beginning there was a poignant awareness of the distance between practice in the New World and the achievements, traditions, and values of the Old, between empirical groping by eager, inadequately trained talents and the well-established precepts and glorious exempla of the grand heritage. Engravings and mezzotints after models of European painting, so keenly sought and exploited by colonial painters, only made the distance more painfully obvious.

An advertisement of 1735 announced the sale in Boston of John Smibert's collection of prints after "the finest pictures in Italy, France, Holland, and England, done by Raphael, Michel Angelo, Poussin, Rubens and other great masters, containing a variety of subjects, as history, etc., . . . being what Mr. Smibert collected in the above-mentioned countries, for his own private use and improvement."[2] Smibert (1688–1751) had arrived on these shores in 1729 with Bishop George Berkeley, to be professor of drawing and painting and architecture in the abortive "universal college of arts and sciences"

that was to be founded for the benefit of the Indians in Bermuda (fig. 1). Trained in London, he had spent several years studying, copying, and acquiring casts as well as prints on the continent. Mementos of European culture hung heavy in Smibert's Boston studio.

In 1759 the young Benjamin West (1738–1820) left his Philadelphia home and set sail for Italy, sponsored by patrons investing in native talent. West thus initiated the return exodus and a long tradition of study abroad for artists from America. He settled permanently in London to embark upon a remarkably successful career. West was followed in 1774 by John Singleton Copley (1738–1815) (fig. 2), who abandoned his Beacon Hill farm in Boston and, as he complained, a "people entirely destitute of all just Ideas of the Arts."[3] To test himself against a higher standard, Copley had already sent pictures for exhibition in London (Color plate I; fig. 27 below), with West reporting their critical reception (generally favorable) and offering advice of his own—to which we shall return. Apologetically explaining his choice of subject, a portrait rather than something more ambitious, Copley wrote from Boston:

> Subjects are not so easily procured in this place. A taste for painting is too much Wanting to afford any kind of helps; and was it not for preserving the resembla[n]ce of particular persons, painting would not be known in the plac[e]. The people generally regard it not more than any other useful trade, as they sometimes term it, like that of a Carpenter tailor or shoemaker, not as one of the noble Arts in the World. Which is not a little Mortifying to me. While the Arts are so disregarded I can hope for nothing, eith[e]r to encourage or assist me in my studies but what I receive from a thousand Leagues Distance, and be my improvements

what they will, I shall not be benefitted by them in this country, neither in point of fortune or fame.[4]

The very practical Benjamin Franklin, proving himself not "entirely destitute of all just Ideas of the Arts," acknowledged that painting and the other arts may indeed be "necessary and proper gratifications of a refined society." However, the newly independent colonies were not yet ready for such aesthetic indulgence. "All things have their season," he declared, "and with young countries as with young men, you must curb their fancy to strengthen their judgment. . . . To America, one schoolmaster is worth a dozen poets, and the invention of a machine or the improvement of an implement is of more importance than a masterpiece of Raphael."[5]

The struggle to recognize painting as more than a "useful trade," as a liberal rather than a mechanical art, had been launched more than three centuries earlier, in Italy, and victory throughout much of Europe had been institutionalized through the establishment of officially sponsored academies that came to complement, if not to replace, the workshop as a place of artistic education. England itself was actually rather late in acknowledging this emancipation: the Royal Academy was founded only in 1768, more than two hundred years after the establishment of the first academy of art in Florence.

Both West and Copley made it to and in London, successful expatriate colonials. Their British academic standing reflected a certain glory on their native land and made London more hospitable to young American painters eager for the chance of "improvement" at the source—West's studio serving as an informal academy, as depicted by Matthew Pratt in 1765 (fig. 3). Neither returned to participate in the birth of aesthetic ambition that followed the estab-

lishment of the United States of America. Independence gave particular direction to that ambition. Instead of bemoaning the lack of cultural opportunity in America and seeking careers abroad, a younger generation of artists now looked back to England for the practical means to realize newly defined goals on this side of the Atlantic. They were inspired by West's own transatlantic transformation of history painting, his insistent sense of reality in representing recent events (fig. 4). Appealing to the "law of the historian," he rejected the grand manner, urged on him by Sir Joshua Reynolds: "I want to mark the date, the place, and the parties engaged in the event," he declared. "If instead of the facts of the transaction, I represent classical fictions how shall I be understood by posterity?"[6]

With that same obligation to the facts, John Trumbull (1756–1843) explicitly identified his art with his country (fig. 5): "The greatest motive I had or have for engaging in, or for continuing my pursuit of painting," he wrote to Thomas Jefferson in 1789, "has been the wish of commemorating the great events of our country's revolution. I am fully sensible that the profession, as it is generally practiced, is frivolous, little useful to society, and unworthy of a man who has talents for more serious pursuits."[7] The well-born, Harvard-educated Trumbull, whose father had refused him permission to study with Copley, hardly considered painting a profession suitable to a gentleman. Nevertheless,

> to preserve and diffuse the memory of the noblest series of actions which have ever presented themselves in the history of man; to give to the present and the future sons of oppression and misfortune, such glorious lessons of their rights, and of the spirit with which they should assert and support them, and even to transmit

to their descendants, the personal resemblance of those who have been the great actors in those illustrious scenes, were objects which gave a dignity to the profession, peculiar to my situation. And some superiority also arose from my having borne personally a humble part in the great events which I was to describe.

Painting was to offer perpetual testimony to history, and this painter in particular, who had served as an aide to George Washington in the field, was to stand as ideal witness (fig. 6).

Beyond "preserving the resemblance of particular persons," this "useful trade" would preserve the record of particular actions. Painting had at last found its noble calling in America: "Vanity was thus on the side of duty," Trumbull declared with a resigned *noblesse*, "and I flattered myself that by devoting a few years of my life to this object, I did not make an absolute waste of time, or squander uselessly, talents from which my country might justly demand more valuable services." History, however, conspired against Trumbull's "national work," as he called his pictorial cycle; his subscription effort for engravings after the designs came at an unpropitious time: "The progress of the French Revolution," he lamented, "was blasting to my hopes."[8] Nonetheless, the artist had sought to define a role for painting in the new nation, a rhetorical and patriotic one. But the ambitious language of history painting was not particularly well understood here. Despite the efforts of Trumbull, of Charles Willson Peale (1741–1827) and his sons, of Washington Allston (1779–1843), and of others seeking to create a monumental figural art of high moral and ethical import—inevitably of academic inspiration—heroic gestures seemed to ring hollow in the new democracy.

Trumbull's ambitions, formulated in London—indeed, directly

inspired by Benjamin West—were essentially Old World and aristocratic in their rhetorical purpose. Back in New York in 1815, he was elected president of the American Academy of the Arts, successor to the New York Academy of the Fine Arts, which had been founded by Robert Livingston to be "a germ of those arts so highly cultivated in Europe, but not yet planted here." The temptation to establish a national academy was strong and was felt in several quarters. As early as 1794 a group of artists had met at Charles Willson Peale's museum in Philadelphia (fig. 7) to consider such an enterprise. Some proposed a kind of American Royal Academy, with the president, rather like the king, as patron; it would be an institution to set the standards and control the arts throughout the new republic. Peale and others, favoring a more professional guild and training program, objected to the foundation of such a "National College." As "citizens of the United States," they protested, "we would not presume to establish a national institution which would place similar institutions in other states in a subordinate position." The federal system itself offered principled argument against such a project: "America is not the soil to foster seeds of such vanity and arrogance. . . . We will leave conceptions so profound as a national college . . . to those who started up from the hot-beds of monarchy, and think themselves lords of the human kind. . . . We are not in monarchical subordination here."[9]

Like history painting, its noblest art, the academic idea found the New World's soil less than hospitable, although each had strong proponents. Democracy, with its pluralist commitment, thwarted such aristocratic ambition; it stood suspicious of the grandly heroic gesture, which seemed ultimately, and inevitably, inspired by the art of "monarchical subordination."

American painting was to find a truer, more convincing national identity when it turned to the country itself, that is, in landscape (fig. 8; color plate II). Horace Walpole had declared Smibert's departure for the New World a kind of pilgrimage "to a new theatre of prospects, rich, warm, and glowing with scenery which no pencil had yet made cheap and common by a sameness of thinking and imagination." He then went on to consider the future of the arts in the New World: "As our disputes and politics have travelled to America, is it not probable that poetry and painting, too, will revive amidst those extensive tracts as they increase in opulence and empire, and where the stores of nature are so various, so magnificent, and so new?"[10]

Almost a century later, in an "Essay on American Scenery" (1835), Thomas Cole (1801–1848) declared it to be "a subject that to every American ought to be of surpassing interest; for, whether he beholds the Hudson mingling waters with the Atlantic—explores the central wilds of this vast continent, or stands on the margin of the distant Oregon, he is still in the midst of American scenery—it is his own land; its beauty, its magnificence, its sublimity—are all his." And, he concludes, "the most distinctive, and perhaps the most impressive, characteristic of American scenery is its wildness." Cole compared the Catskills with the Alps, the Hudson with the Rhine; but Europe had no Niagara (fig. 9), nor could it match the "luxury of color" of the American forest in autumn.[11]

Cole directly confronted the cultural objection: "what has been considered a grand defect in American scenery—the want of associations, such as arise amid the scenes of the old world." To which he responded: "American scenes are not destitute of historical and legendary associations—the great struggle for freedom has sanctified

many a spot, and many a mountain, stream, and rock has its legend, worthy of poet's pen or the painter's pencil" (fig. 10). "But," and here Cole appropriates his subject to the larger vision, "American associations are not so much of the past as of the present and the future." Verbally laying out a general American scene, visual description becomes ethical interpretation: "You see no ruined tower to tell of outrage—no gorgeous temple to speak of ostentation; but freedom's offspring—peace, security, and happiness, dwell there, the spirits of the scene." He paints a specifically American pastoral, whose woods are informed by the political virtues, the benefits of the new order. Unlike the retrospection of the European pastoral, with its nostalgia for antiquity, the American looks instead to the future: "And in looking over the yet uncultivated scene, the mind's eye may see far into futurity. Where the wolf roams, the plough shall glisten; on the gray crag shall rise temple and tower—mighty deeds shall be done in the now pathless wilderness; and poets yet unborn shall sanctify the soil."

In 1829 William Cullen Bryant had rhymed that pledge to the American landscape in his poem "To Cole, the Painter, Departing for Europe":

Thine eyes shall see the light of distant skies;
Yet, Cole! thy heart shall bear to Europe's strand
A living image of our own bright land,
Such as upon thy glorious canvas lies.
Lone lakes—savannahs where the bison roves—
Rocks rich with summer garlands—solemn streams—
Skies where the desert eagle wheels and screams—
Spring bloom and autumn blaze of countless groves.

Bryant's apostrophe to the American scene, and to his friend's painting of it, sets up the inevitable comparison, a warning to the wandering son against the blandishments of foreign temptation:

Fair scenes shall greet thee where thou goest—fair
But different—everywhere the trace of men.
Paths, homes, graves, ruins, from the lowest glen
To where life shrinks from the fierce Alpine air.
Gaze on them, till the tears shall dim thy sight,
But keep that earlier, wilder image bright. [12]

The foreign artifice of personification and allegory may well have been necessary to the establishment of an official national symbolism—as, for example, in Charles Willson Peale's representation, in a portrait of a toga-clad William Pitt, of an Indian with "a Bow in his hand, and a Dog by his Side, to show the natural Faithfulness and Firmness of America."[13] But, to a more natural vision, Cole's landscape imagery carried the values of the country. More even than the flag was her nature the true symbol of America, its purpose and its destiny, the icon inspiring devotion. In his funeral oration on the death of the artist, in 1848, Bryant added to the patriotism of Cole's vision just that spiritual dimension. Of his paintings his friend declared, "it hardly transcends the proper use of language to call them acts of religion" (fig. 11).[14]

Rejecting the inherited gods and values of the European pantheon, America's poets and painters celebrated the deity of their own land. Even Tocqueville acknowledged the democratic poetry of such "embellished delineation of all the physical and inanimate objects which cover the earth," and he described its sources:

When skepticism had depopulated heaven, and the progress of equality had reduced each individual to smaller and better-known proportions, the poets, not yet aware of what they could substitute for the great themes that were departing together with the aristocracy, turned their eyes to inanimate nature. As they lost sight of gods and heroes, they set themselves to describe streams and mountains.[15]

The phenomenon of such aesthetic nationalism is not without precedent, of course, in the Old World. Dutch landscape painting of the early seventeenth century, to cite a prime example, honored a land that had only recently declared its political independence, from Hapsburg Spain, which followed its physical independence as land reclaimed from the sea. More immediately relevant, aesthetically if not politically, is John Constable's defense of a specifically English landscape, a native landscape that can be so "embodied by highest principles as to become classical art."[16]

In America, however, landscape was invested with an even greater responsibility: to become not "classical art" but rather a uniquely American art, one that reflected the particularities of the new country. "If art in America is ever to receive any distinctive character so that we can speak of an American School of Art," wrote Worthington Whittredge (1820–1910), "it must come from this new condition, the close intermingling of the peoples of the earth in our peculiar form of government. In this I have some hope for the future of American Art. We are a very young nation to stand as well as we do in art compared to the people of the old world." Whittredge—who had studied painting in Dusseldorf, like many of his generation, and had traveled widely in Europe—saw the

future of an American art in "our young artists, especially the landscape painters."[17]

The goal became all the more precious in response to the perception, repeated often and not only by Europeans, that art could find no legitimate place in this rough, self-righteously virtuous country. "There is no poetical ground-work for the artist in our country and time," observed Margaret Fuller Ossoli in 1839, commenting on an exhibition of paintings by Washington Allston. "We have no established faith, no hereditary romance, no such stuff as Catholicism, Chivalry afforded. What is most dignified in the Puritanic modes of thought is not favorable to beauty. The habits of an industrial community are not propitious to delicacy of sentiment."[18]

As if in response, Horatio Greenough (1805–1852)—himself the Romanizer of George Washington in marble—complained about such generalized assumptions in his "Remarks on American Art" (1843): "The susceptibility, the tastes, and the genius which enable a people to enjoy the Fine Arts, and to excel in them, have been denied to the Anglo-Americans, not only by European talkers, but by European thinkers." Americans were presumably too busy exploring and taming the wilderness, building ships and cities, creating laws and defending them to develop a high culture—or to put "statues or frescoes in our log-cabins." Europeans, Greenough reports, "assert that there is a stubborn, antipoetical tendency in all that we do, or say, or think; they attribute our very excellence in the ordinary business of life, to causes which must prevent our development as artists."[19]

The "progress" of art in America emerges as a central theme in the cultural apologetics of the first half of the nineteenth century; it is declared outright in the title of William Dunlap's survey of the situation in 1834: *A History of the Rise and Progress of the Arts of Design in the*

United States. Indeed, the very writing of a work such as Dunlap's doubly documents its subject. The publication of this American Vasari, a retrospect, itself testified to the progress of the arts in this country. The writing of history more than confirms history: it creates it.

The persistent call, from the artists themselves, for a national identity in and through art colored aesthetic commentary. It defined both the task of the artist and the terms of response to his imagery. After claiming for American purpose Constable's goal of the "natural landscape painter," Asher Brown Durand (1796–1886) concluded the second of his "Letters on Landscape Painting" (1855) with the following peroration:

> I desire not to limit the universality of Art, or require that the artist shall sacrifice aught to patriotism; but, untrammelled as he is, and free from academic or other restraints by virtue of his position, why should not the American landscape painter, in accordance with the principle of self-government, boldly originate a high and independent style, based on his native resources? ever cherishing an abiding faith that the time is not far remote when his beloved Art will stand out amid the scenery of his "own green forest land," wearing as fair a coronal as ever graced a brow "in that Old World beyond the deep."[20]

By the end of the nineteenth century landscape could hardly function in the same way, as a sign of America's freedom and potential—the railroad standing out as only the most obvious symbol of a closing frontier (fig. 12). Instead of pointing to the future, as it had for Cole, the landscape was becoming a record of the American past. Once-forested terrain now served as the setting for human habita-

tion and industry, for economic and social activity. The call for an American art, however, continued to be heard. If the land seemed no longer to offer the basis for a pictorial response—an appeal to values that could be called American, values that could be measured against those of Europe—that call nonetheless continued to inform the aesthetic rhetoric.

The rather ponderous title of an essay of 1909 by Robert Henri (1865–1929), a leading anti-academic painter (fig. 13) and influential teacher, epitomizes the national thesis: "Progress in Our National Art Must Spring from the Development of Individuality of Ideas and Freedom of Expression: A Suggestion for a New Art School." Henri addressed the issue directly:

> There has been much discussion within the last year on the question of a national art in America. We have grown to handle the subject lightly, as though it were a negotiable quantity, something to be noted in the daily record of marketable goods. And the more serious have talked much about "subject" and "technique," as though if these were acquired, this desired thing, a national art, would flourish quickly and beautifully; whereas, as a matter of fact, a national art is not limited to a question of subject or of technique, but is a real understanding of the fundamental conditions personal to a country, and then the relation of the individual to these conditions.

Henri's discourse expands upon the patriotic faith in America and a democratic faith in the American:

> And so what is necessary for art in America, as in any land, is first an appreciation of the great ideas native to the country and then

the achievement of a masterly freedom in expressing them. Take any American and develop his mind and soul and heart to the fullest by the right work and the right study, and then let him find through this training the utmost freedom of expression, a fluid technique which will respond to every inspiration and enthusiasm which thrills him, and without question his art will be characteristically American, whatever the subject.

Ambivalent about "subject" and "technique," Henri reaches for larger, more universal values that are, nonetheless, quintessentially American, rooted in the country:

Before art is possible to a land, the men who become the artists must feel within themselves the need of expressing the virile ideas of their country; they must demand of themselves the most perfect means of so doing, and then, what they paint or compose or write will belong to their own land. First of all they must possess that patriotism of soul which causes the real genius to lay down his life, if necessary, to vindicate the beauty of his own environment. And thus art will grow as individual men develop, and become great as our own men learn to think fearlessly, express powerfully and put into their work all the strength of body and soul.[21]

However insufficient, "subject" and "technique" remain necessary, central to the vision, now bold and masculine. Champion of an open technique of paint handling, Henri invests that technical freedom with a higher ethical value. And the vindication of "the beauty of his own environment" necessarily turns the artist to his choice of subject.

By the turn of the twentieth century that environment was already predominantly urban. Henri, like the other realists of the so-called Ash Can School—inspired by the Dutchmen Rembrandt and Hals as well as by the French master of proletarian technique, Courbet— championed vigorous paint handling and a commitment to tonal structure (fig. 14). Such a mode of painting matched the special vigor of their chosen subject matter, the American urban scene (fig. 15). Indeed, throughout the first half of the twentieth century, the search for an American art seemed inevitably to identify with the selection of subject: the social and physical realities of urban life, transformed by new waves of immigration; the impressive structures of industrialization; the injustices of an exploitative system; or, as though in response to such realities, the proud humility of rural America. Realists, Precisionists (fig. 16), Social Realists, Regionalists (fig. 17)—to each, style per se seemed to matter less than thematic commitment, which remained, in however varied a fashion, possessed by that "patriotism of soul" invoked by Henri.

What these alternative modes shared in particular was a sense of difference from Europe. That measure continued to haunt the progress of an American art, even as it served to define it, and the advent of a radical modernism in Europe only reinforced aesthetic xenophobia on these shores. Speaking for a larger constituency than he perhaps knew, Henri declared "the most elaborate imitation of art grown in France or Germany" to be "valueless to a nation compared with product that starts in the soil and blooms over it." The great confrontation came, of course, in 1913, with the International Exhibition of Modern Art, the Armory Show. Here, for the first time, Americans met a significant representation of recent European art, and here, for the first time, American art could measure itself directly against that foreign challenge.

Response to the Armory Show was, to say the least, mixed. Most famously, Theodore Roosevelt, moved by Marcel Duchamp's *Nude Descending a Staircase* (fig. 18), compared that painting to "a really good Navajo rug" in his bathroom, which he found, "on any proper interpretation of the Cubist theory, a far more satisfactory and decorative picture."[22] The conservative painter Kenyon Cox (1856–1919) also invoked the decorative arts to indict Cubism: "A Turkish rug or a tile from the Alhambra is nearly without representative purpose, but it has intrinsic beauty and some conceivable human use." "The real meaning of this Cubist movement," he warned, "is nothing else than the total destruction of the art of painting—that art of which the dictionary definition is 'the art of representing, by means of figures and colors applied on a surface, objects presented to the eye or to the imagination.'"[23] Total aesthetic anarchy, of foreign importation, seemed imminent.

Significantly, and understandably, Cox reserved some of his harshest criticism for an American participant, a former student of his (fig. 19): "It has remained for Mr. Marsden Hartley to take the final step and to arrange his lines and spots purely for their own sake, abandoning all pretense of representation or even of suggestions. He exhibits certain rectangles of paper covered with a maze of charcoal lines which are catalogued simply as Drawing No. 1, Drawing No. 2, and so forth." But Hartley (1877–1943) was already expatriate. First in Paris and then in Berlin and Munich, he became familiar with the work of Picasso and, especially, Kandinsky—whose titling by genre and number he shared.

Even before his departure for Europe in 1912, Hartley had encountered such art, at Alfred Stieglitz's gallery 291, which had become a center of avant-garde modernism in America; there, artists

kept in closer touch with developments abroad, and most of them actually made the pilgrimage to Paris. For this group, at least, the Armory Show held little surprise. For others, however, it was eye-opening (fig. 20): "the greatest shock to me," Stuart Davis confessed, "—the greatest single influence I have experienced in my work. All my immediately subsequent efforts went toward incorporating Armory Show ideas into my own work." Discovering Gauguin, Van Gogh, Matisse, and Cézanne and the Cubists, Davis recalls, "I resolved that I would quite definitely have to become a 'modern artist'" (fig. 21).[24]

It was difficult for a painter, particularly a young painter, not to respond to the radically new art of the Europeans. In most cases, however, the initial enthusiasm led to no lasting conversion. The young Thomas Hart Benton (1889–1975), for example, participated creatively in the Synchromism of Stanton Macdonald-Wright (1890–1973) (fig. 22), but he publicly repented that early lapse and turned to a true American alternative (fig. 23). Speaking for himself and his fellow Regionalists, John Steuart Curry (1897–1946) and Grant Wood (1892–1942), Benton later recalled,

We were all in revolt against the unhappy effects which the Armory Show of 1913 had had on American painting. We objected to the new Parisian aesthetics which was more and more turning art away from the living world of active men and women into an academic world of empty pattern. We wanted an American art which was not empty, and we believed that only by turning the formative processes of art back again to meaningful subject matter, in our cases specially American subject matter, could we expect to get one.[25]

More interesting, perhaps, is the response of Davis, who pledged himself to become a "modern" artist. For all his modernist commitment—to the formal structures of Picasso, Léger, and Matisse—he too remained very much a painter of the American scene. Davis had studied with Henri, and his observations on that education are suggestive of the tensions that continued to inform his own work:

> The borderline between descriptive and illustrative painting, and art as an autonomous sensate object, was never clarified. Because of this, reliance on the vitality of the subject matter to carry the interest prevented an objective appraisal of the dynamics of the actual color-space relations on the canvas. I became vaguely aware of this on seeing the work at the Armory Show.

Whatever his resolve to become a "modern" artist, Davis never really abandoned the lessons of Henri, above all the importance of "subject" as well as "technique." And that subject was ostentatiously American (fig. 24). Insisting that "modern pictures deal with contemporary subject matter in terms of art," he declared that all his pictures have "their originating impulse in the impact of the contemporary American environment." They were inspired, inter alia, by:

> American wood and iron work of the past; Civil War and skyscraper architecture; the brilliant colors on gasoline stations, chain-store fronts, and taxicabs; . . . electric signs; the landscape and boats of Gloucester, Mass.; 5 & 10 cent store kitchen utensils; movies and radio; Earl Hines hot piano and Negro jazz music in general, and the like.[26]

Not quite Whitman perhaps, this inventory of Americana deter-mines the look of his pictures, which, in turn, become, as he says, "a new part of the American environment. Paris School, Abstraction, Escapism?" Davis asks rhetorically. "Nope," he responds, "just Color-Space Compositions celebrating the resolution in art of stresses set up by some aspects of the American scene." Adopting "some of the methods of modern French painting which I consider to have universal validity," the American painter, with a kind of Yan-kee reticence, asserts his national identity: "I am an American, born in Philadelphia of American stock. I studied art in America. I paint what I see in America, in other words, I paint the American scene."[27]

Davis tried to have it both ways, simultaneously to be a modern artist and an American artist. Was such double commitment possi-ble under the laws of aesthetic patriotism? Was foreign style adapt-able to the representation of the American scene? In its own way, Davis's struggle was heroic, an internal aesthetic dilemma that assumed ethical dimensions. Acknowledging that dilemma, he was effectively summing up the particular situation of his art in this country over the past two hundred years and giving voice to a chal-lenge that was being met with new imaginative energy by some of his younger contemporaries.

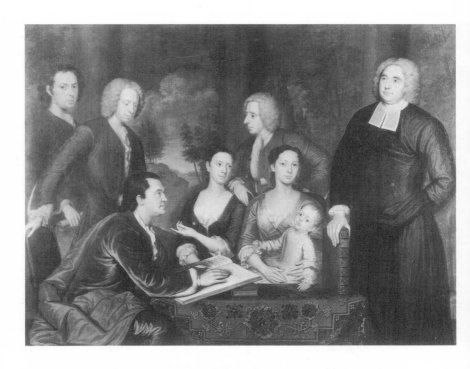

FIGURE 1. John Smibert, *Dean George Berkeley and His Entourage (The Bermuda Group)*, 1729–1739. Oil on canvas, 69 1/2 x 93 inches. Yale University Art Gallery, New Haven, Connecticut; Gift of Isaac Lothrop (1808.1).

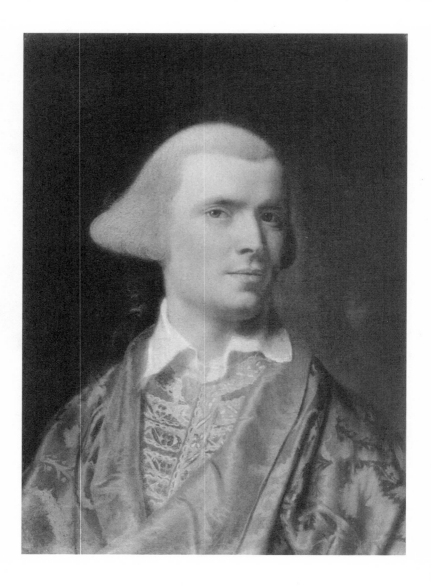

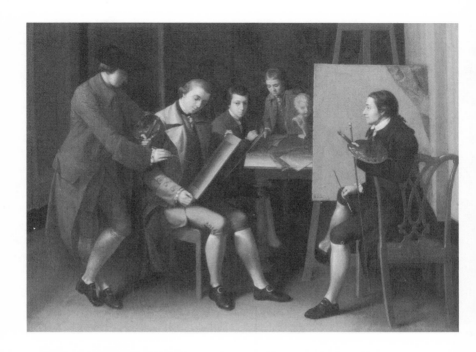

FIGURE 3. Matthew Pratt, *The American School*, 1765. Oil on canvas, 36 x 50 1/4 inches. The Metropolitan Museum of Art, New York; Gift of Samuel P. Avery, 1897 (97.29.3).

FIGURE 2. (*Opposite*). John Singleton Copley, *Self-Portrait*, ca. 1770. Pastel on paper, 23 1/4 x 17 1/2 inches. The Winterthur Museum, Winterthur, Delaware; Gift of Henry Francis du Pont (1957.1127A).

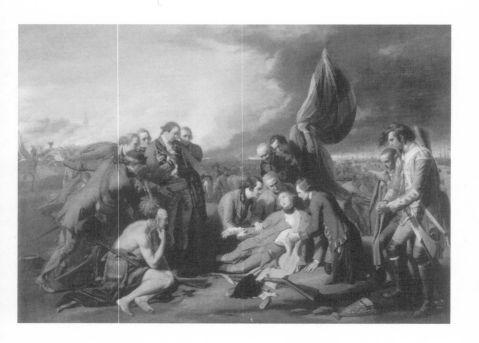

FIGURE 4. Benjamin West, *The Death of General Wolfe*, 1770. Oil on canvas, 60 1/2 x 84 inches. National Gallery of Canada, Ottawa.

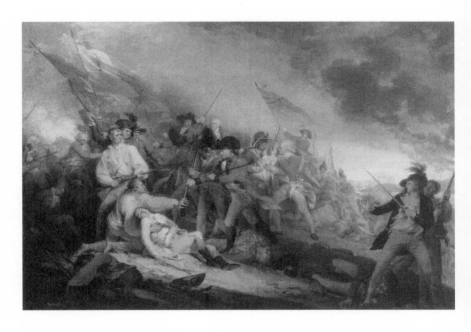

FIGURE 5. John Trumbull, *The Death of General Warren at the Battle of Bunker's Hill*, 1786. Oil on canvas, 25 5/8 x 37 5/8 inches. Yale University Art Gallery, New Haven, Connecticut; Trumbull Collection (1832.1).

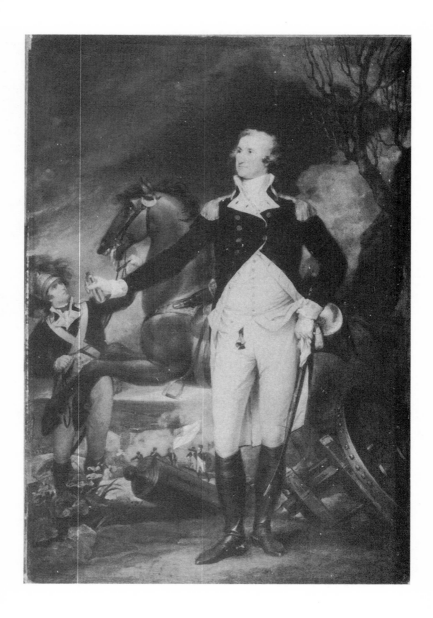

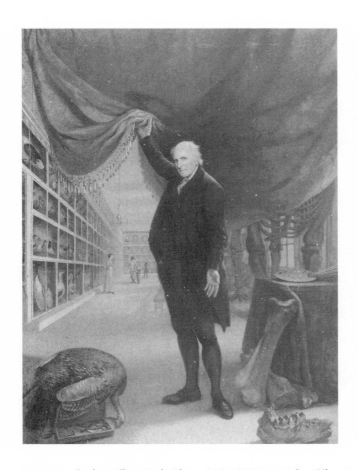

FIGURE 7. Charles Willson Peale, *The Artist in His Museum*, 1822. Oil on canvas, 103 3/4 x 79 7/8 inches. Courtesy of the Pennsylvania Academy of the Fine Arts, Philadelphia; Gift of Mrs. Sarah Harrison (The Joseph Harrison Jr. Collection) (1878.1.2).

FIGURE 6. (*Opposite*). John Trumbull, *George Washington Before the Battle of Trenton*, ca. 1793. Oil on canvas, 26 1/2 x 18 1/2 inches. The Metropolitan Museum of Art, New York; Bequest of Grace Wilkes, 1922 (22.45.9).

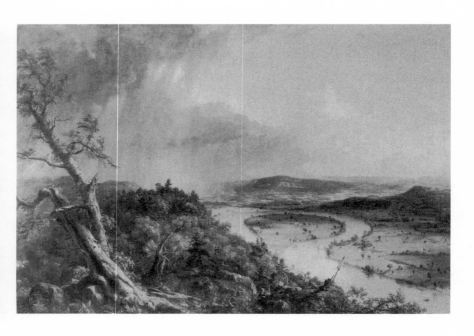

FIGURE 8. Thomas Cole, *The Oxbow (View from Mt. Holyoke, Northampton, Mass., After a Thunderstorm)*, 1836. Oil on canvas, 51 1/2 x 76 inches. The Metropolitan Museum of Art, New York; Gift of Mrs. Russell Sage, 1908 (08.228).

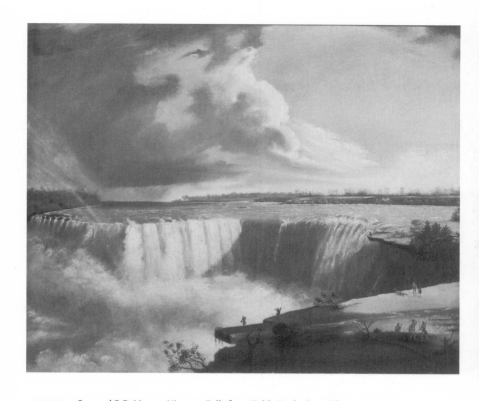

FIGURE 9. Samuel F. B. Morse, *Niagara Falls from Table Rock*, 1835. Oil on canvas, 24 x 30 inches. Museum of Fine Arts, Boston; Bequest of Martha C. Karolik for the M. and M. Karolik Collection of American Paintings, 1815–1865 (48.456).

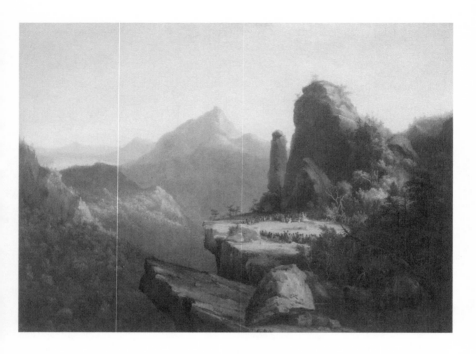

FIGURE 10. Thomas Cole, *Scene from "The Last of the Mohicans": Cora Kneeling at the Feet of Tamenund*, 1827. Oil on canvas, 25 3/8 x 35 1/16 inches. The Wadsworth Atheneum, Hartford, Connecticut; Bequest of Alfred Smith (1868.3).

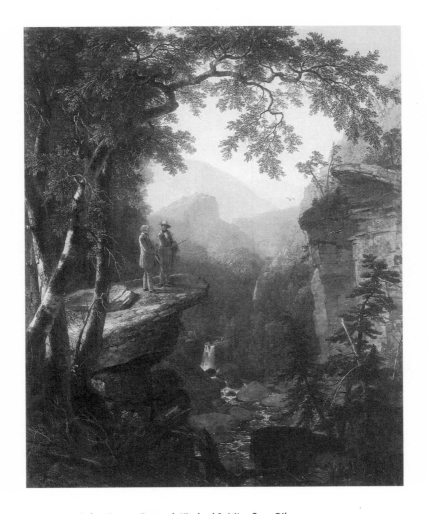

FIGURE 11. Asher Brown Durand, *Kindred Spirits*, 1849. Oil on canvas, 44 1/8 x 36 1/16 inches. Collections of The New York Public Library, Astor, Lenox, and Tilden Foundations.

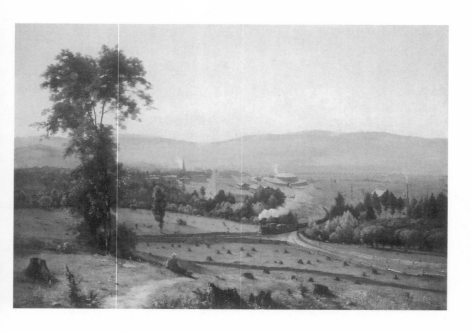

FIGURE 12. George Inness, *The Lackawana Valley*, ca. 1856. Oil on canvas, 33 7/8 x 50 3/16 inches. National Gallery of Art, Washington, D.C.; Gift of Mrs. Huttleston Rogers (1945.4.1).

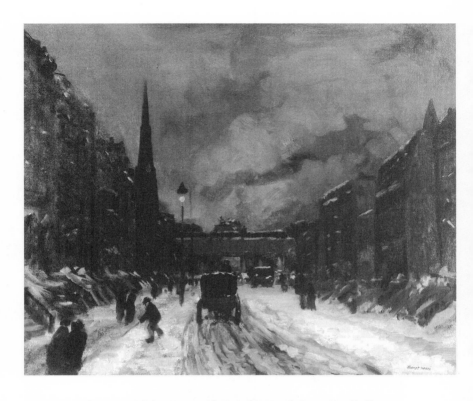

FIGURE 13. Robert Henri, *Street Scene with Snow (West 57th Street, New York)*, 1902. Oil on canvas, 26 x 32 inches. Yale University Art Gallery, New Haven, Connecticut; The Mabel Brady Garvan Collection (1947.185).

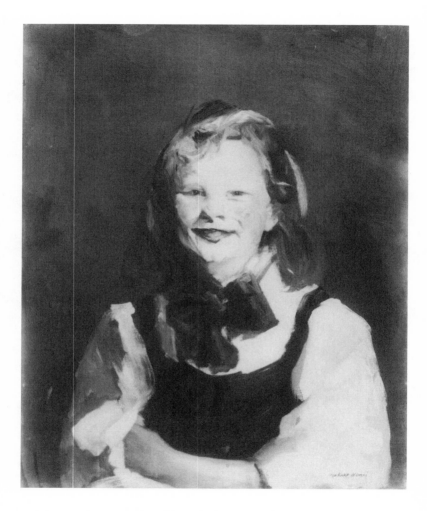

FIGURE 14. Robert Henri, *Laughing Girl*, 1910. Oil on canvas, 24 1/4 x 20 1/4 inches. The Brooklyn Museum; Frank S. Benson Fund (12.93).

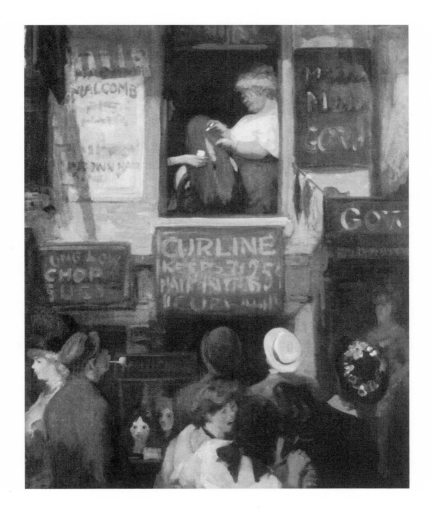

FIGURE 15. John Sloan, *Hairdresser's Window*, 1907. Oil on canvas, 31 7/8 x 26 inches. The Wadsworth Atheneum, Hartford, Connecticut; The Ella Gallup Sumner and Mary Catlin Sumner Collection Fund (1947.240).

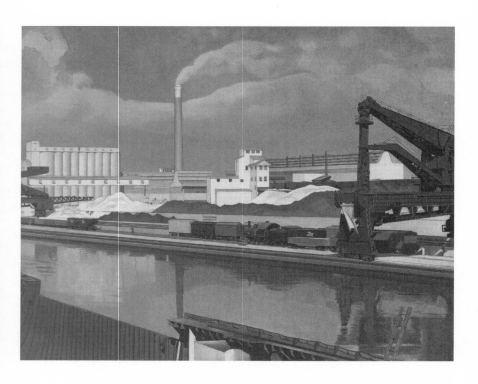

FIGURE 16. Charles Sheeler, *American Landscape*, 1930. Oil on canvas, 24 x 31 inches. The Museum of Modern Art, New York; Gift of Abby Aldrich Rockefeller (166.1934). Digital image © The Museum of Modern Art / Licensed by SCALA / Art Resource, New York.

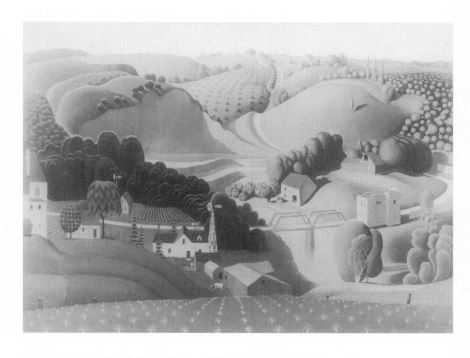

FIGURE 17. Grant Wood, *Stone City*, 1930. Oil on composition board, 30 1/4 x 40 inches. Joslyn Art Museum, Omaha, Nebraska. © Estate of Grant Wood / Licensed by VAGA, New York, New York.

FIGURE 18. Marcel Duchamp, *Nude Descending a Staircase, No. 2*, 1912. Oil on canvas, 57 7/8 x 35 1/8 inches. The Philadelphia Museum of Art; The Louise and Walter Arensberg Collection (1950-134-59). © 2003 Artists Rights Society (ARS), New York / ADAGP, Paris / Succession Marcel Duchamp.

FIGURE 19. (*Opposite*). Marsden Hartley, *Painting No. 1*, 1913. Oil on canvas, 39 3/4 x 31 7/8 inches. Sheldon Memorial Art Gallery and Sculpture Garden, University of Nebraska–Lincoln.

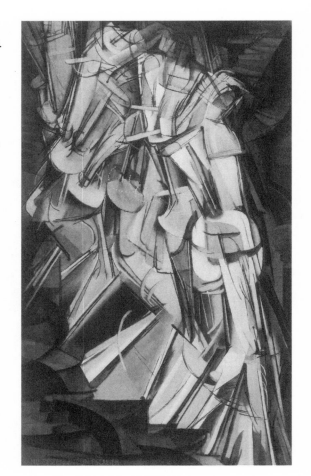

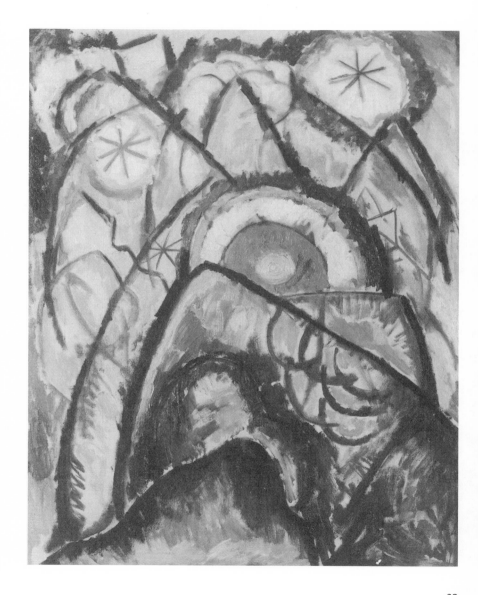

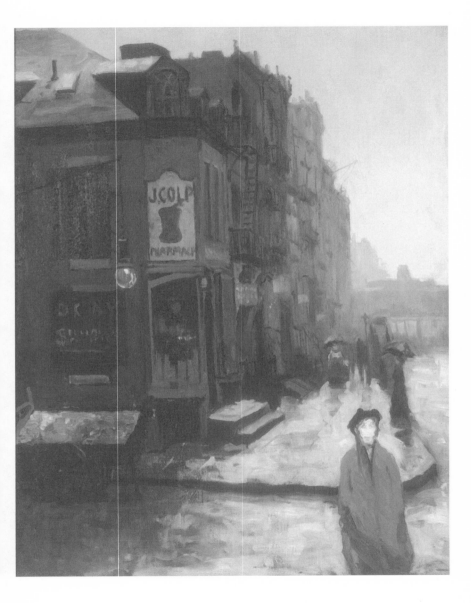

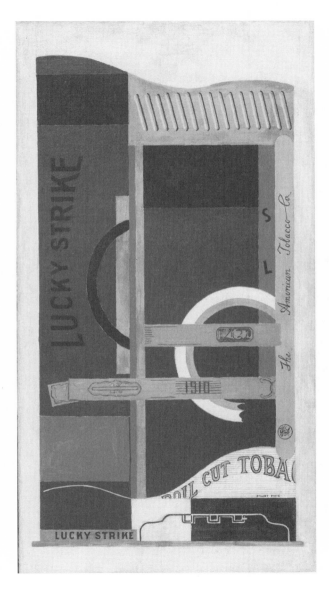

FIGURE 21. Stuart Davis, *Lucky Strike*, 1921. Oil on canvas, 33 1/4 x 18 inches. The Museum of Modern Art, New York; Gift of the American Tobacco Company, Inc. (132.1951). © Estate of Stuart Davis / Licensed by VAGA, New York, New York. Digital image © The Museum of Modern Art / Licensed by SCALA / Art Resource, New York.

FIGURE 20. (*Opposite*). Stuart Davis, *Bleeker Street*, 1913. Oil on canvas, 38 x 30 inches. Collection Earl Davis. Courtesy of Salander–O'Reilly Galleries, New York. © Estate of Stuart Davis / Licensed by VAGA, New York, New York.

41

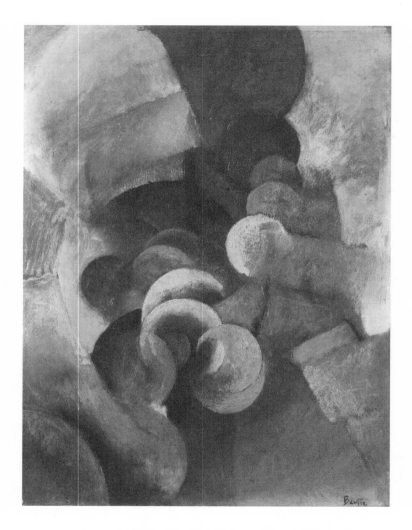

FIGURE 22. Thomas Hart Benton, *Bubbles*, 1914–1917. Oil on canvas, 22 x 17 inches. The Baltimore Museum of Art; Gift of H. L. Mencken, Baltimore (BMA 1947.317).© T. H. Benton and R. P. Benton Testamentary Trusts / Licensed by VAGA, New York, New York.

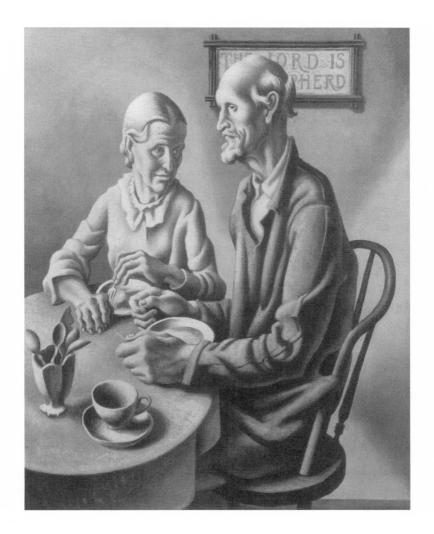

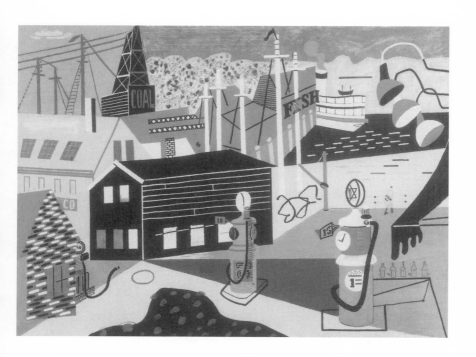

FIGURE 24. Stuart Davis, *Landscape with Garage Lights*, 1932. Oil on canvas, 32 x 41 7/8 inches. Memorial Art Gallery of the University of Rochester; Marion Stratton Gould Fund (51.3). © Estate of Stuart Davis / Licensed by VAGA, New York, New York.

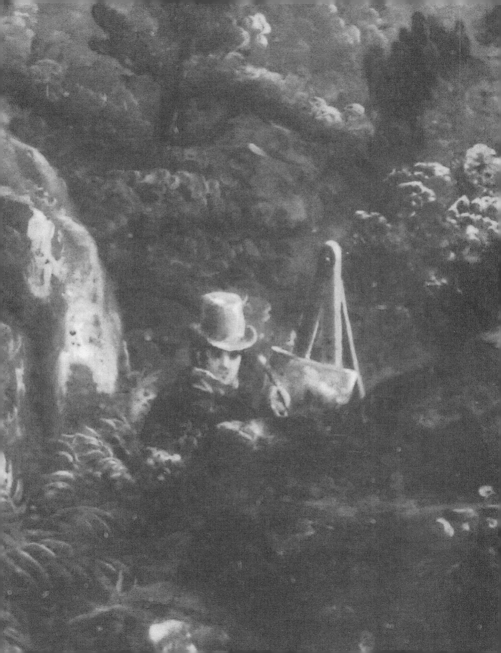

> *It's more noble to be employed in serving and supplying the necessities of others, than merely in pleasing the fancy of any. The Plow-Man that raiseth Grain, is more serviceable to Mankind, than the Painter who draws only to please the Eye. The Carpenter who builds a good House to defend us from Wind and Weather, is more serviceable than the curious Carver, who employs his Art to please the Fancy.*
>
> Anonymous

TWO *Style and the Puritan Aesthetic*

The anonymous author of *An Addition to the Melancholy Circumstances of the Province Considered*, published in Boston in 1719,[1] undoubtedly spoke for those colonials who, a generation or more later, were to be rejected by John Singleton Copley as a "people entirely destitute of all just Ideas of the Arts" (fig. 25).[2] Against such utilitarian priority, Copley was to object, from the aesthetic haven of Rome: "There is a kind of luxury in *seeing* as well as there is in eating and drinking; the more we indulge, the less we are to be restrained!"[3] That was a luxury he discovered in Italy and which he continued to pursue in London (fig. 26).

In 1765, nearly a decade before he abandoned Boston, Copley painted the portrait of his younger stepbrother, Henry Pelham—the

painting generally known as the *Boy with a Squirrel*—and sent it to be exhibited in London (fig. 27; color plate I). This was to be the test of colonial American talent. Could it hold its own at the Society of Artists? Evidently it did, as Copley learned from the already expatriate Benjamin West, who reported its reception, including one demurring criticism: "while it was Exhibited to View the Criticism was, that at first Sight the Picture struck the Eye as being to liney, which was judged to have arose from there being so much neatness in the lines, which indeed as far as I was Capable of judgeing," West confesses somewhat apologetically, "was some what the Case."[4] Forgiving the tautology of West's explanation, we may take his point. He was essentially reporting the opinions of Sir Joshua Reynolds himself, who had praised the picture, pronouncing that, in the light of the "Dissadvantages" the young artist labored under in New England, "it was a very wonderful performance." Still, the dean of British painters found certain faults: "a little Hardness in the Drawing, Coldness in the Shades, An over minuteness."[5]

Copley's precision—the focused attention he devotes to individual objects, his slow and deliberate exploration of textures and surfaces, of reflections and highlights, the isolation of parts, and exact bounding of colors—was seen as predominating over the larger coherence of the picture, the parts distracting from the whole. A more sympathetic viewing of the *Boy with a Squirrel* might discover the broader relationships that do indeed structure the composition—the curves that relate the backdropped curtain and the poignantly tilted head of the sitter, the careful blocking of color fields, the studied inflections of hue and of tone—and the special sensibility that unites boy and pet: the delicate chain linking the two, the soft aura surrounding the open eye of each (fig. 28).

Indeed, the *Boy with a Squirrel* seems to us much less "liney" than many of Copley's American portraits (e.g., fig. 29). More softly rendered, more affectively planned, indirect in its address, it is closer to what the eighteenth-century English might have called a "fancy" picture. Copley's portraits tend to be much more forthright, object-oriented images of sitters objectified. They lack what Reynolds was to call "the Genius of mechanical performance," that dexterity of brush whereby "a greater quantity of truth may be said to be contained and expressed in a few lines or touches, than in the most laborious finishing of the parts" (e.g., fig. 30).[6] "Laborious finishing of the parts" is exactly what distinguishes Copley's pictures. We sense in each depicted object an investment of time as well as labor, an intensity of concentration that sometimes leads to a certain disproportion of the parts (fig. 31). That intensity, of long looking and patient imitation, fixes the object, investing it with a correspondingly insistent presence within the picture.

In the portrait of Mrs. Ezekiel Goldthwait (fig. 32) or, more famously, that of Paul Revere (fig. 33), Copley's act of looking is matched not only by the returned gazes of the sitters but, even more immediately, more tangibly, by their own contact with the world that surrounds them. Mrs. Goldthwait reaches for the crowning fruit in the copious bowl, her hand curving to receive its rounded form. Paul Revere grasps the silver teapot he will presently engrave, his fingers merging with the polished surface and through their reflection penetrating it (fig. 34); his other hand supports his head, the primary object confronting the painter.

Copley's pictured world is one of stereometric values, of surfaces explored and plotted, asserted and denied. Light seems initially in the service of formal definition, until through reflection it transfig-

ures the material surfaces of the forms it makes visible. Every thing and every surface presents its own challenge to the painter, and that challenge is accepted in earnest. Copley encounters the objects before him in a physical way; staring at them with intensity—an intensity confirmed by our own encounter with their simulacra—he masters them, individually, by imposing himself on them, grasping them, bringing them under his control. The prehensile gestures of the sitters serve as mimetic metaphor for the painter's own attack. Copley's is a haptic art.

Within the seriousness of the task before him there is neither room nor use for the overt display of the painter's technique, that "mechanical dexterity" urged by Reynolds, the ostentatious stroke of the brush. Without the examples of actual paintings by Titian, Rubens, or, of most direct relevance, Van Dyck, and knowing European masters essentially through prints after their work, the colonial artist in America could hardly be expected to understand the ways of the brush. As Copley wrote to West, "In this Country as You rightly observe there are no examples of Art, except what is to [be] met with in a few prints indifferently exicuted, from which it is not possible to learn much."[7] And yet, the very lack that so haunted him became for Copley a special source of strength. Each task became a struggle, a problem to be solved, and we respond to the outcome; we sense the work behind each image, the personal investment of the painter. Confronted with the mimetic challenge of the object, and without the benefit of traditional technical apprenticeship, he had, in effect, to invent the art of painting anew.

From the beginning, the artist in the New World created with a nervous and forced intensity. He lacked the security and support afforded the European painter by the venerable traditions of Style,

the accumulated aesthetic standards and technical practices of generations, worked out in the studios of the masters and codified in the academies. Style—that is, the aesthetic self-awareness of the art, realized in and through technique—provided the artist with a sense of identity; it offered a lens through which reality was viewed and transformed, the means by which Nature was turned into Art. Without inherited European manners, the American colonial artist forged his own relationship with Nature on a fundamentally empirical basis. Without the reassuring guide and protection of Style, he had few automatic solutions to the myriad problems of picture-making, and so the rendering of each and every object became a demanding task. The object was not transformed by the knowing stroke of the brush, but, with painstakingly grim determination, the painter set out to reproduce it, to replicate it. Nor did the object willingly yield to the new aesthetic context, participating in the larger pictorial order of things; rather, it obstinately insisted on its unique identity, its own reality.

In America, Art seemed to bow before Nature; the subject of the painting triumphs over the art of painting. Out of the artist's mimetic struggle with the object arises a basic respect for it; out of the struggle to imitate the artist learns humility. And his picture offers the viewer a surrogate experience, the chance to feel the challenge of the object, to feel it directly, unmediated. Only reluctantly does the artist allow his own presence to disturb the transparency of the picture plane, to question the suspension of disbelief.

Style, with all its cultural and social implications, was what Copley sought when he set out for Europe in 1774. In London he did indeed develop a sense of the brush as an instrument unwilling to efface itself from the surface (fig. 35). The critical consensus of pos-

terity might deplore Copley's abandonment of native strength for acquired habit, but even in his English portraits we recognize a peculiar deliberateness that still carries a New England accent. Even as his stroke aspires to the freedom, lightness, and fluidity of a grander manner, it nonetheless retains a certain slowness, a pondered touch that recalls, however distantly, his earlier aesthetic (fig. 36). Accounts of Copley at work in London confirm that he continued to engage directly with the object before him, that the superficial brilliance of his acquired technique was just that, superficial.

In his *History of the Rise and Progress of the Arts of Design* William Dunlap reports, second hand, the opinion of Gilbert Stuart "that no man ever knew how to *manage paint* better than Copley. I suppose," Dunlap comments, "he meant that *firm*, artist-like manner in which it was applied to the canvas; but he said he was very tedious in his practice."[8] Stuart's point is fully confirmed by stories of complaining sitters, impatient and wearied from long hours of posing. Even Benjamin West, Copley's champion, admitted he was "the most tedious of all painters"—according to Charles R. Leslie, "When painting a portrait, he used to match with his palette knife a tint for every part of the face, whether in light, shadow, or reflection. This occupied himself and the sitter a long time before he touched the canvas."[9] The very discrepancy between such a practice and the surface ambition of Copley's English manner suggests just how deeply ingrained it must have been. Between the color of Nature and the color of Art there was to be as little difference as possible, between the sitter and his or her effigy as little distance. In such a mimetic mode the brush can play only the most humble mediating role—a function most honestly fulfilled in Copley's American work. Bravura brushwork, attesting to inspired spontaneity, could hardly be bothered with such obligation.

The brush stroke—the directed application of pigment to the surface of the painting, the touch that retains its independence as a mark, resisting sacrifice of its own reality in the service of illusion—asserts the claims of Art over Nature. Operating at the aesthetic core of painting, chiding the mimetic pretense of the art even as it participates in the seduction of the viewer, its implications have always been problematic. The stroke is what most properly belongs, above all else in the art, to the painter—"the mechanical practice of [his] own particular art" (Reynolds). His own unique mark, it stands for the artist; it is his trace. When asked why he did not sign or mark his work, Gilbert Stuart (1755–1828)—the first American painter to master the independent brush stroke, in London—responded, "I mark them all over" (fig. 37).[10] The stroke, as signature, affirms the presence of the artist in the work. In Copley's American portraits we sense instead the disappearance of the artist. His presence is reconstituted only through our own direct relationship to the objects with which he had engaged: we replicate the experience of the artist in seeing, not in making. Not on the surface of his canvases but rather through the faces of Mrs. Goldthwait or Paul Revere, and in the things of their world, do we meet the painter Copley.

An ambivalence must inhere in the complexity of such a relationship to the picture and its maker, now relocated in the illusion of his own creation. Initially, we are encouraged to approach the image with a deep, even naïve belief in the reality of the imitated object, to see through the surface. This, in turn, necessarily implies a respect for the painted image itself, for the art that can command such faith. The resulting dialectic, potentially a source of aesthetic pleasure for those prepared to appreciate the game, can also yield, in another

value system, a different kind of synthesis: a consequent mistrust of the image as false, a deception.

An ethical imperative runs strong in American aesthetic thought, however tacit at times. We might choose to call it puritan. Unwilling to accept the ideal reality of the Aesthetic, implicitly claimed by Style, the American remains somewhat uneasy before an image, responding to it less as a representation of an object, a recreation on another level, than as a substitute for it. Such an attitude can easily lead to iconoclasm, inspiring the colonial preacher's solemn injunction against the graven image. Suspicion and fear of the image—and a corollary perverse fascination with it—are born of an inability, or unwillingness, to isolate and define aesthetic experience, a difficulty in distinguishing Art from Life.

With creative naïveté, Charles Willson Peale could invent a pictorial genre he called a "deception." Or, more accurately, reinvent: Pliny the Elder offered ancient pedigree for such imagery, paintings intended to efface themselves entirely in deceiving the eye. In Peale's *Staircase Group* (fig. 38), featuring his sons Raphaelle and Titian on a flight of stairs ascending from an open doorway, the tall canvas is set within an actual door frame and the lowest step, constructed of wood, extends out from the surface into the viewer's space: an American Baroque. Dimly lit, the picture's illusion was powerful enough, we are told, to cause George Washington himself to greet the painted figures with a bow. So too in Raphaelle Peale's (1774–1825) *Venus Rising from the Sea—A Deception* (fig. 39), where the ostensible subject of the title is covered by an illusionistically draped cloth, an invitation to the viewer to lift it and so gaze upon the uncovered nude goddess—as ancient Zeuxis had been tempted by the painted curtain of Parrhasios: American painters knew their Pliny (*Natural History* 35.65).

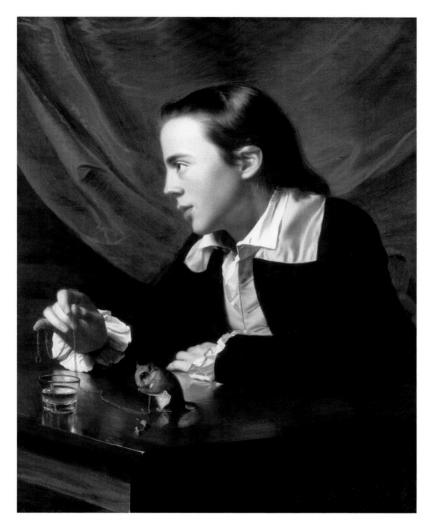

COLOR PLATE I. John Singleton Copley, *Henry Pelham (Boy with a Squirrel)*, 1765. Oil on canvas, 30 3/8 x 25 1/8 inches. Museum of Fine Arts, Boston; Gift of the artist's great-granddaughter (1978.297). Photograph © 2004 Museum of Fine Arts, Boston.

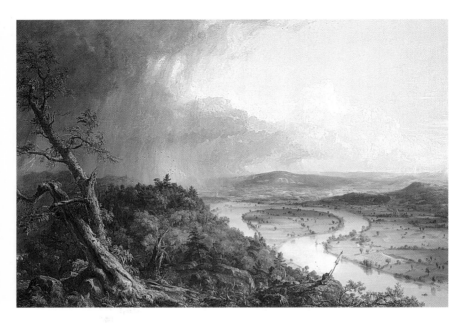

COLOR PLATE II. Thomas Cole, *The Oxbow (View from Mt. Holyoke, Northampton, Mass., After a Thunderstorm)*, 1836. Oil on canvas, 51 1/2 x 76 inches. The Metropolitan Museum of Art, New York; Gift of Mrs. Russell Sage, 1908 (08.228). Photo © 1995 The Metropolitan Museum of Art.

COLOR PLATE III. (*Opposite*). Thomas Eakins, *John Biglin in a Single Scull*, 1874. Oil on canvas, 24 3/8 x 16 inches. Yale University Art Gallery, New Haven, Connecticut; Whitney Collections of Sporting Art, given in memory of Harry Payne Whitney, B.A. 1894, and Payne Whitney, B.A. 1898, by Francis P. Garvan, B.A. 1897, M.A. (Hon.) 1922 (1932.263).

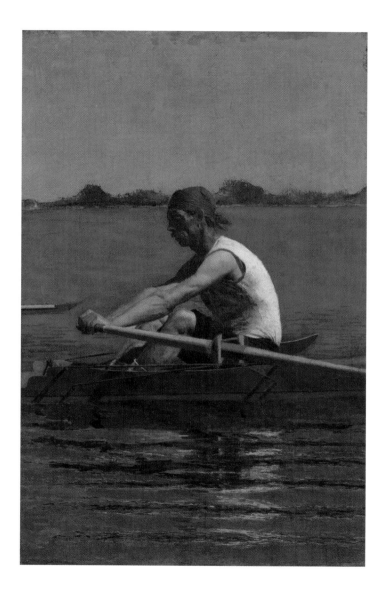

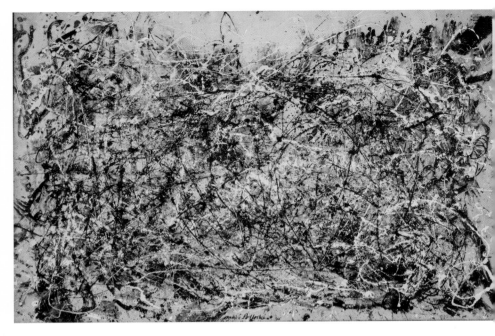

COLOR PLATE IV. Jackson Pollock, *Number 1A, 1948*, 1948. Oil and enamel on canvas, 68 x 104 inches. The Museum of Modern Art, New York; Purchase (77.1950). © 2003 The Pollock-Krasner Foundation / Artists Rights Society (ARS), New York. Digital image © The Museum of Modern Art / Licensed by SCALA / Art Resource, New York.

For all their naïve verisimilitude, the very conceit of such deceptions implies the knowing operations of the painter's art. There is, then, a level of professional self-consciousness in these pictures that is absent from Copley's American portraits. Still, both depend upon the transparency of the picture plane, the disappearance of the executing hand. Such self-effacement, personal or pictorial, implies a suspicion of painting itself, an uneasiness with the willful imitation of reality. In the competition between Art and Nature, Nature sets the rules.

Nowhere did Nature make its claims on Art more than in landscape painting. From the earliest views of American scenery the appeal of such imagery had been specific, to a particular locale or feature of the land—most spectacularly, of course, Niagara Falls (see fig. 9 above). And that appeal to the specific continued to inform landscape aesthetics. Thomas Cole's earlier landscapes especially manifest a commitment, not unlike Copley's, to the objects of nature (fig. 40). Rugged surfaces, tangible in their particularity of form and execution, offer immediate tactile access to the world beyond the picture plane; collectively, through their singular mimetic conviction, they establish the reality of the painted landscape, offering a foothold, as it were, for the eye. Each of these forms, we sense and know, has been the object of intense observation, scrutinized individually. From his various drawings done from nature—detailed studies (fig. 41) or schematic sketches complete with color notations or distances marked (fig. 42)—Cole assembled his pictures back in the studio (fig. 43).

This dissociation of seeing and composing was essential to Cole's practice and to his developing aesthetic: "My desire and endeavour is always to get the objects of nature, sky, rocks, trees, etc. as strongly

impressed on my mind as possible, and by looking intently on an object for twenty minutes I can go to my room and paint it with much more truth, than I could if I employed several hours on the spot." His sketches preserved, as he said, "the beautiful impress of nature," the result of "looking intently." In his paintings, however, he sought to unite "the most lovely parts" in "a whole that shall surpass in effect any picture painted from a single view. . . . If I am not misinformed," he adds with apologetic uncertainty, "this had been the practice of the Old Masters."[11] In his sketches and studies and even in the individual parts of his finished paintings, Cole was the intense observer and obedient servant of Nature. As a self-conscious artist, however, a composer of pictures, he refused to "shackle the imagination" to what the eye sees (fig. 44).

Following his European sojourn (1829–1832) and increasingly through his career, Cole aspired to a nobler expression than mere landscape, seeking the higher symbolic modes of allegory and metaphor. He would not be "a mere leaf painter." In that refusal he enacted the paradox of his own art, that dissociation of seeing and composing. By 1826 the conflict itself had been eloquently documented, in the correspondence with his Baltimore patron, Robert Gilmor Jr. Interestingly, it was the patron who rejected the cultural pretensions of the painter, the ambition to create "compositions," to improve upon Nature through Art. At immediate issue was the recent work of Thomas Doughty (1793–1856), whose landscapes were variously catalogued as either "from nature" or "from recollection" or, more ambitiously, as imaginary "compositions." In Gilmor's view, these deliberately artificial landscapes (fig. 45) lacked his earlier "pleasing variety of nature."

As long as Doughty studied and painted from Nature (who is always pleasing from even slightly rendered drawings or paintings made on the spot) his pictures were pleasing, because the scene was real, the foliage varied and unmannered, and the broken ground and rocks and masses had the very impress of being after originals and not ideals. . . . I prefer real American scenes to compositions, leaving the distribution of light, choice of atmosphere and clouds, and in short all that is to render its natural effect as pleasing and spirited as the artist can feel permitted to do, without violation of its truth.[12]

We are back then to the disappearance of the artist in the work. Gilmor's defense of the purity of landscape representation in fact anticipates the grander transcendental view that was soon to dominate American aesthetic thought. Asher Brown Durand (1796–1886) too, in turning to landscape, and following the example of Cole, went directly to nature. "The luxury of nature is so fascinating to my senses," he confessed, "that I feel no disposition for anything but attempting to imitate her beauties, not by any actual view but by catching some lovely features" (fig. 46).[13] And he recorded those "features" in drawings and in oil sketches, remarkable for their sense of substance (fig. 47). Combined into compositions back in the studio, these motifs, articulated pieces of nature, validated through their tactile immediacy the mimetic credentials of the painting. Indeed, however much Durand may have learned from European models, especially about atmospheric unity, the particular strength of his paintings lies in the conviction of individual objects.

Durand's intimate studies convey the humility before nature that

he himself was to preach, that sense of privilege before a higher order of beauty to be found even "by the common roadside." In the second of his letters on landscape painting, published in the journal *The Crayon* in 1855, he urged, in Ruskinian fashion, the study of nature not only for professional reasons but for "its influence on the mind and heart. The external appearance of our dwelling-place, apart from its wondrous structure and functions that minister to our well-being, is fraught with lessons of high and holy meaning, only surpassed by the light of Revelation."[14] If the Book of Nature is open to all to read, the artist, through the privileged quality of his vision, serves as minister: "The artist as a poet will have seen more than the mere matter of fact, but no more than is there and that another may see if it is pointed out to him." A landscape, on this view, is "great in proportion as it declares the glory of God and not the works of man." Paintings, as William Cullen Bryant had said in his funeral oration for Cole, may properly be called "acts of religion."

"Before nature," Durand writes in an essay on "Studying from Nature," "you are to lose sight of yourself, and seek reverently for the truth, neither being captious as to what its qualities may be or considering whether your manner of telling it may be the most dexterous and draughtsmanlike. It is not of the least consequence whether *you* appear in your studies or not—it is of the highest importance that they should be true."[15]

With less conventional piety and greater breadth of vision, Ralph Waldo Emerson had pondered the relationship of Nature to Art and the consequences for the artist, in his "Thoughts on Art" of 1841. His axiomatic principle: "The universal soul is the alone creator of the useful and the beautiful; therefore to make anything useful or beautiful, the individual must be submitted to the universal mind." How-

ever little he himself may have been moved by the visual arts, Emerson actually gives fullest voice to an attitude we have been tracing: "the genius of the artist" must bow before Nature. Considering "the works that have beauty for their end, that is, the productions of the Fine Arts," he declares, "the prominent fact is the subordination of man. His art is the least part of his work of art."

> I say that the power of Nature predominates over the human will in all works of even the fine arts, in all that respects their material and external circumstances. Nature paints the best part of the picture; carves the best part of the statue; builds the best part of the house.[16]

In Emerson's transcendental economy of correspondences it is precisely through this "law" that both the work of art and the artist participate in the greater scheme of things. The work "must be strictly subordinated to the laws of Nature, so as to become a sort of communication, and in no wise a contradiction of Nature; . . . so that it shall be the production of the universal soul." And the artist who is to produce a work of more than parochial value, one worthy of universal admiration, "must disindividualize himself. . . . He must work in the spirit in which we conceive a prophet to speak, or an angel of the Lord to act, that is, he is not to speak his own words, or do his own works, or think his own thoughts, but he is to be an organ through which the universal mind acts." Like Emerson himself, the artist is invited to become a "transparent eyeball," which, in seeing all, becomes nothing.

We return then to that related transparency, the picture plane, the surface at which truths are tested. Durand—who found in the

brushed textures of the oil sketch, and indeed of his finished paintings, correlative for the rough realities of rock, bark, and foliage—was not one to disappear entirely at the confrontation. Nonetheless, he brought what I am calling a puritan aesthetic to that surface, a morally charged fear of its temptations. Sounding an old note in warning against mixing the spiritual and the material, he preaches:

> We cannot serve God and mammon, however specious our garb of hypocrisy; and I would sooner look for figs on thistles than for the higher attributes of Art from one whose ruling motive in its pursuit is money. This is one of the principal causes operating to the degradation of Art, perverting it to the servility of a mere trade; and next to this, is its prostitution by means of excess of color, strong effects and skillful manipulation, solely for the sensuous gratification of the eye.[17]

There is no room here for that "kind of luxury in *seeing*" that Copley had discovered in Italy. The sequence of Durand's condemnation is, to say the least, interesting, and the rising note of hysterical outrage unmistakable. That "mechanical dexterity" in which Reynolds and a long European tradition located the excellence of the art of painting is to be shunned; the "Genius of mechanical performance" is branded a harlot. Durand's discomfort with strong color, and his corollary commitment to tonal values, cannot be written off simply as a consequence of his early training as an engraver. Whatever the practicalities of training, the issue has been escalated to a matter of principle. The atmospheric tonality that he favored enabled passage through the painting, effectively dematerializing the picture plane. Color and "skillful manipulation" of the brush stop the eye; they

proclaim the surface—and, therefore, the artist. "A picture so painted . . . may well be considered but an empty decoration," Durand pronounces with righteous certitude.

> But fortunately for Art, it is only through the religious integrity of motive by which all real Artists have ever been actuated, that it still preserves its original purity, impressing the mind through the visible forms of material beauty, with a deep sense of the invisible and immaterial, for which end all this world's beauty and significance . . . , beyond the few requirements of our animal nature, seems to be expressly given.

The artist is to be praised "who has kept in due subordination the more sensuous qualities with which material beauty is invested," whose work affirms "our spiritual nature, and scorns the subtlety and logic of positive philosophy."

The theme we have been following, of the American painter's pledge of allegiance to Nature, to the reality rendered, may seem to rehearse older debates in the history of art. The alternatives of drawing and coloring—a choice known to antiquity, first fully articulated in the Renaissance, and subsequently codified in the academies—had always carried ethical implications: drawing represents closed form, structural firmness, objectivity, commensurability, reason; lacking those virtues, color represents instead subjectivity and sensuousness, superficiality and, finally, dissolution both formal and, by extension, moral. In America, however, the debate, like painting itself, develops on its own, independent of the critical tradition of Europe. Confronting the natural object, whether colonial sitter or Catskill scenery, American painters recognized their charge as being

fundamentally mimetic. Responsive to the reality before them and seeking to reconstruct it on the painted surface, they transferred the initial intensity of looking into an intensity of making. Whatever they may have learned from masters or models, each encounter seems a fresh discovery; each rendering apparently has to invent, to discover its own means of imitation. This primitivism, as we might call it, accords that independent existence to objects that we have observed in Copley, in Cole, and in Durand, and that so eloquently stills the luminist views of Fitz Hugh Lane (1804–1865) (fig. 48), Martin Johnson Heade (1819–1904) (fig. 49), and John Frederick Kensett (1816–1872) (fig. 50)—"a lightness, a brilliancy, a *crudity*, which allows perfect liberty of self-assertion to each individual object in the landscape," as Henry James, himself with some training in the art, observed of his imagined Cragthorpe air in 1866.[18]

Cole had expressed similar reactions to color and facture in painting during his European trip. His "*natural* eye," responding to brightly colored English landscape painting, was "disgusted with its gaud and ostentation." Turner, once considered "one of the greatest landscape painters that ever lived," had become the "prince of evil spirits," turning landscape into "jellies and confections" because of an "undue dislike of dullness and black." It wasn't natural. After all, "Nature in her exquisite beauty abounds in darkness and dullness. Above all," Cole concludes, "she possesses solidity."[19] In a diary entry of April 28, 1839, he welcomed the invention of Daguerre and Talbot as "a great revolution in Pictorial Art," trusting that

it will have the effect of annihilating the false & lying Artists who of late have deluged the world with their productions, those things called *views*, purporting to be sketched on the spot, effect

put in in London & elsewhere by some favourite manufacturer of blotch & blaze. Nature herself will now confront the liars in paint & black & white, and their monstrosities will be revealed to the eyes of the much abused public.[20]

Forty-five years later (1884) we hear a similar note of complaint in George Inness's (1825–1894) embittered response to French Impressionism, Monet's work in particular (fig. 51). Proper painting aims at rendering the "solidity of objects and transparency of shadows in a breathable atmosphere through which we are conscious of spaces and distances. By the rendering of these elements," he continues, "we suggest the invisible side of painting, and the want of that grammar gives to pictures either the flatness of silhouette or the vulgarity of overstrained objectivity." Durand's ethical warning becomes Inness's Yankee outrage: "For when people tell me that the painter sees nature in the way Impressionists paint it, I say 'Humbug' from the lie of intent to the lie of ignorance."[21] A painting, as Durand said, "should be true," and that means it must yield its own, manufactured reality, its own objecthood, to that of the nature represented. For Inness, Monet's "pancake of color," the insistent surface allegiance of stroked pigment, simply would not do.

In the course of his development, Inness's own painting shifts from an earlier emphasis on the "solidity of objects," realized through a corresponding firmness of paint application (see fig. 12 above), toward greater reliance on the "transparency of shadows in a breathable atmosphere," in which his own brushwork, always more independent than that of his American colleagues, loosens appreciably (fig. 52). We might even be tempted to trace that course as one from realism to impressionism, but this American's more open stroke

remains committed to that perceptible atmosphere, to the invitation of "spaces and distances" beyond the picture plane. Although no other American painter of the nineteenth century was as comfortable with the possibilities of the brush as a purely expressive vehicle, was as respectful of its apparently random marks, Inness nonetheless insisted upon the essential transparency of the picture plane. For all the unusual brilliance of his colors and the large-scale patterning of his compositions, it was the world beyond pictorial surface that mattered. "Spaces and distances": the medium of spatial continuity is essentially tonal—and the application of glowing glaze to the painted surface assured that color served that end. The occasional correlation of stroke with color functions, even in the vigorously worked surfaces of his later canvases, essentially as a punctuation of that continuum, as spatial articulation.

In American pictures that have often commanded comparison with French Impressionist paintings for choice of subject and plein air approach, the distinguishing feature remains that fundamental commitment to atmosphere, "the power which defines and measures space—an intangible agent," as Durand had explained, "visible, yet without that material substance which belongs to imitable objects, in fact, an absolute nothing, yet of mighty influence. It is that which above all other agencies, carries us into the picture, instead of allowing us to be detained in front of it."[22] With unwitting precision, Durand located the fundamental dilemma at the threshold of illusion, at the picture plane.

The graded continuity of values built upon a tonal ground, implying spatial sequence as well as formal substance, provided the base for a pictorially reconstituted reality. Even as he constructed up and down, toward light and dark, in the tonal system of his technique the

American painter imagined a firm grasp on the substances coming into being, tactile and tangible. And in that system the individual stroke of the brush, no matter how discretely assertive, remained obedient to the notional reality it was called upon to render.

As much as any painter, Winslow Homer (1836–1910) exploited the substance of paint structure to build his pictures (fig. 53). Like Durand, he brought to the studio his experience as a draftsman, an illustrator in black and white. His paintings translate that essentially binary mode into a chromatic context, juxtaposing large, clearly defined areas of light and color against a darker ground. As he found his natural rhythm as a painter, Homer was able to realize that structural breadth more immediately through his handling of the brush; his stroke gained in security, becoming broader, his brush more loaded. "He sees not in lines, but in masses," as Henry James reported, uneasily, in 1875, "in gross, broad masses." If only those masses were "sometimes a trifle more broken," James went on, "and his brush a good deal richer—if it had a good many more secrets and mysteries and coquetries, he would be, with his vigorous way of looking and seeing, even if fancy in the matter remained the same dead blank, an almost distinguished painter."[23] The sophisticated critic could only regret that design never became fully a function of stroke. Homer's honest brush remained committed to the realist enterprise—"the truth of values." Its textures, stubbornly mimetic, were responsive to the virtual surfaces of things rendered rather than to the actual surface of the canvas. Ultimately, that basic commitment to the object may well account for the uneasy effect of Homer's most ambitious waves, their curiously stilled life (fig. 54).

A more interesting measure of what by now we can identify as a fundamental American realism is offered by the most deliberate

realist among our nineteenth-century masters, Thomas Eakins (1843–1916). An American with solid academic credentials—certified by a period of study with Gérôme in Paris—and a fierce commitment to fact, Eakins too developed a sense of light and color against an underlying tonal ground. His efforts to bring the world of things and appearance under rigorous pictorial control, however, were predicated on a more insistent rationalism, a need, almost Quattrocento in its urgency (and which we sense in viewing his work), to subject appearances to the complex rule of perspective (figs. 55, 56; color plate III). The remarkably precise drawings that analytically construct Eakins's rowing pictures fix the elusive patterns of reflection in water, tame them for the rigid geometry of the foreshortened grid—as, reaffirming his studies in Paris, he notes the *limité des reflets dans les vagues*.[24] A uniquely American brand of impressionism, more empirical than the French, the system subjects surface phenomena to a sternly positivist structural logic, willing commensurability upon rippling waves of light.

Similar concerns with visual phenomena were leading Eakins's French contemporaries to very different pictorial conclusions. For Monet, most obviously, patterns of reflected light and color translated directly into sensations of touch: through the brush, the visual is rendered tactile (fig. 57). The atmosphere that Durand had postulated as an extensive horizontal continuum, following the laws of aerial perspective, becomes in Monet's Impressionism a vertical plane, a substantial reinforcement of the canvas surface effectively blocking virtual access to a painted fiction beyond. Eakins's perspective projections, however, are not simply a naïve limner's effort at mere imitation. Their analytic method, inscribed on the surface, yielded sequences of discretely bounded small fields, each to be

assigned a distinct value. Eakins's system did ultimately refer pictorial decisions back to the picture plane, but only after a fundamental logical transformation—subjective perception rationalized through geometry and made objective.

Eakins stands as a true heir to Copley (fig. 58). The very intensity of his vision, his confrontation with the world out there and his need to dominate it, translates into a certain uneasiness in his paintings, a mistrust of the surface, of the reality of painting itself: the mistrust that we have been identifying as a continuing trait in the American tradition. Within the chiaroscuro of his interior settings Eakins distributes a few discrete areas of bright color. Involving deliberate chromatic choice and subtle inflection of hue, the method might legitimately be compared to that of Manet. But Eakins's deep tonal structures, sustaining penetrable space, cannot but charge those notes of color with an affective weight not to be found in the French artist's work. Even as moments of aesthetic self-consciousness, studied gestures of effect, within the deep realism of their setting these chromatic assertions participate in the fictional world of their paintings; their existence is of that world. Eakins himself was certainly capable of bold brushwork, especially in the oil sketches that prepared his finished canvases. Nevertheless, he remained committed to a more methodical and deliberately controlled technique, indeed academic, involving glazing and overpainting—the kind of material build-up that seeks ultimately to disguise the substantial, painted reality of the surface on which it lies.

The puritan aesthetic in American painting is predicated not on iconoclasm, not on the rejection of imagery, but rather on the strongest identification with the notional reality of the image. Hardly a uniquely American attitude, it nonetheless assumes a par-

ticularly consistent expression in our art, one that draws its conse-
quences in regard to the artist and his presence in the work—ideally,
that is, his absence. Seeing through the picture plane not only affirms
the reality of the object beyond—landscape vista, portrait sitter, nar-
rative anecdote—it also means seeing past the hand of the artist,
effectively ignoring it. In time, of course, the social conditions of art
and the values it embodies change; different thematic material pre-
dominates, and new expectations are brought to images. Still,
through the course of its history, painting in America has manifested
a continuing commitment to the truth value of the image, that is, to
the fiction behind the picture plane.

The consistency of that aesthetic may best be gauged in America's
encounters with modernism. I do not refer only to the obvious reac-
tions of Social Realists or Regionalists, to their ideological appeal,
however differently motivated, to native subject matter. Rather, it is
the essential appeal to subject matter per se that seems to me char-
acteristic, the insistence on recognizable and presumably significant
object matter (to borrow Meyer Schapiro's useful distinction), even
by confessedly "modern" American artists (cf. figs. 21, 24 above). Stu-
art Davis's identification with the American scene, by which he tem-
pered the lessons of his French models, exemplifies the situation. Or,
we might cite the Precisionism of Charles Demuth (1883–1935) (fig.
59) and Charles Sheeler (1883–1965) (fig. 60), in which an early
engagement with Cubism is modified to accommodate an essentially
realist agenda. Or the Expressionism of Marsden Hartley (fig. 61), in
which surface is indeed asserted, but, bedecked with insignia,
thereby becoming a field of insistent legibility. Equivocation was
crucial to the operations of pioneering modernists like Picasso and

Kandinsky in their redefinitions of the rules of painting. Although initially inspired by such radical examples, America's early modernists tend to drift back through the picture plane. The lessons of European modernism become reduced to technical means—the transparency of planes, the liberation of color, the imposition of surface pattern—which then are applied to an older, more conservative project (fig. 62).

The American painter draws back from the implications of aesthetic revolution. The images he or she creates maintain a referentiality of insistent specificity; they invite us to look beyond their surfaces to something else. American rebellion in art is, we might say, social rather than formal, thematically rather than structurally directed. That is not to say that American painters did not experiment, did not explore new possibilities. They certainly did, but within what we perceive to be a relatively circumscribed agenda. They achieved the look of modernism without, however, finally testing its premises for themselves.

The absence of a strong academic tradition in this country, an official institution, an establishment style and set of values, hobbled the possibilities of reaction and rebellion. As we scan the history of painting in America we may be struck less by the development of conventions and traditions than by a persistent individualism, not Whitman's bold celebration of the self but rather a more humble sense of individual responsibility to the calling, to a vocation that had to prove itself more than a "useful trade." Able to take so little for granted, the American painter maintains a vocational earnestness before his art, a deadpan, that somehow precludes the play element. Each of our masters seems, in some fundamental way, to have discovered the rules of

art on his own—and to have wondered at the discovery and that miraculous access to a world beyond the picture plane. Each seems to have reinvented the art of painting—and implicitly, in all humility, himself. That self, however, an artistic self, could only find its position in society problematic.

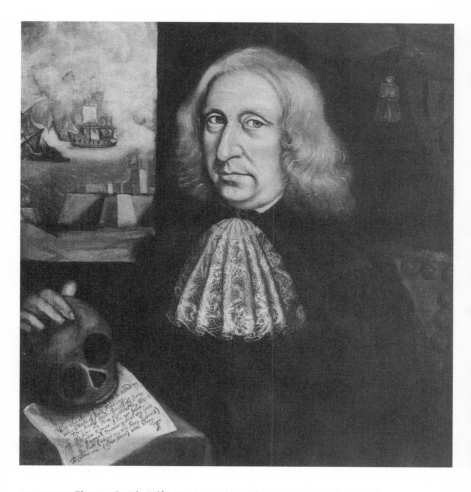

FIGURE 25. Thomas Smith, *Self-Portrait*, ca. 1680. Oil on canvas, 24 5/8 x 13 9/16 inches. Worcester Art Museum, Worcester, Massachusetts; Museum Purchase (1948.19).

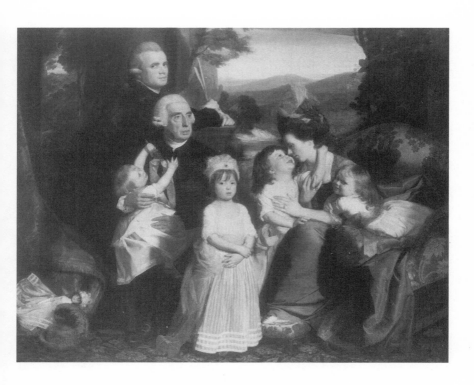

FIGURE 26. John Singleton Copley, *The Copley Family*, 1776/1777. Oil on canvas, 72 1/2 x 90 1/4 inches. National Gallery of Art, Washington, D.C.; Andrew W. Mellon Fund (1961.7.1).

FIGURE 27. (*Opposite*). John Singleton Copley, *Henry Pelham (Boy with a Squirrel)*, 1765. Oil on canvas, 30 3/8 x 25 1/8 inches. Museum of Fine Arts, Boston; Gift of the artist's great-granddaughter (1978.297).

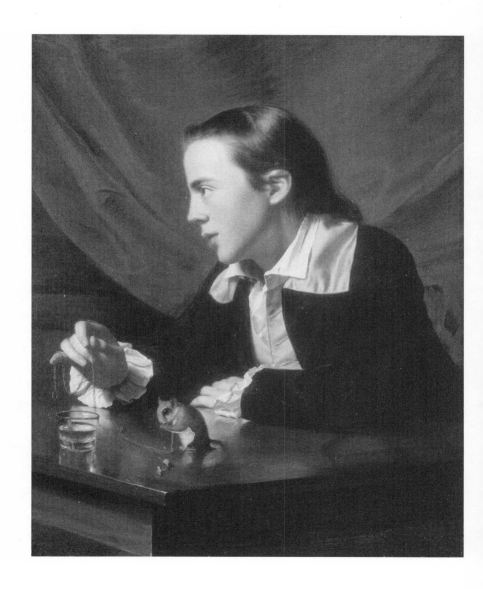

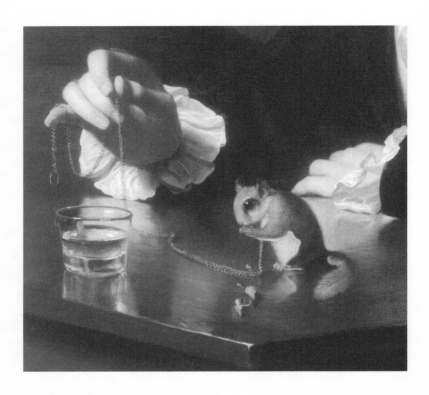

FIGURE 28. Copley, *Henry Pelham* (detail).

FIGURE 29. (*Opposite*). John Singleton Copley, *John Hancock*, 1765. Oil on canvas, 49 1/2 x 40 1/2 inches. Museum of Fine Arts, Boston; Deposited by the City of Boston (L-R 30.76d).

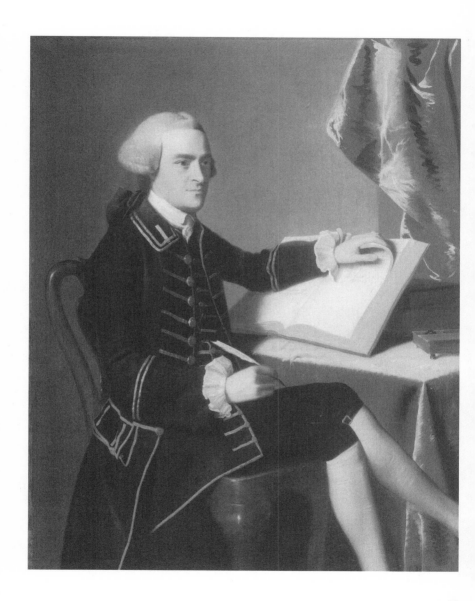

FIGURE 30. William Hogarth, *The Shrimp Girl*, ca. 1745. Oil on canvas, 25 x 20 3/4 inches. National Gallery, London.

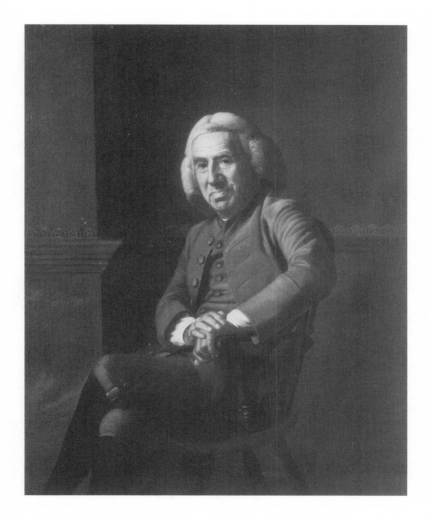

FIGURE 31. John Singleton Copley, *Eleazer Tyng*, 1772. Oil on canvas, 49 3/4 x 40 1/8 inches. National Gallery of Art, Washington, D.C.; Gift of the Avalon Foundation (1965.6.1).

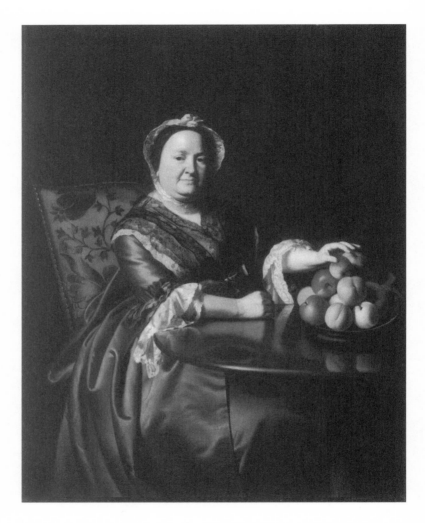

FIGURE 32. John Singleton Copley, *Mrs. Ezekiel Goldthwait (Elizabeth Lewis)*, 1771. Oil on canvas, 50 1/8 x 40 1/8 inches. Museum of Fine Arts, Boston; Bequest of John T. Bowen in memory of Eliza M. Bowen (41.84).

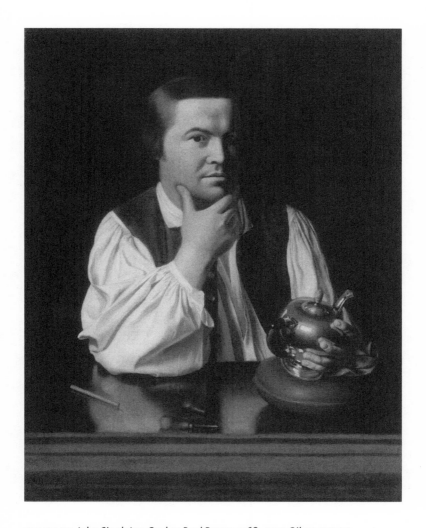

FIGURE 33. John Singleton Copley, *Paul Revere*, 1768–1770. Oil on canvas, 35 x 28 1/2 inches. Museum of Fine Arts, Boston; Gift of Joseph W., William B., and Edward H. R. Revere (30.781).

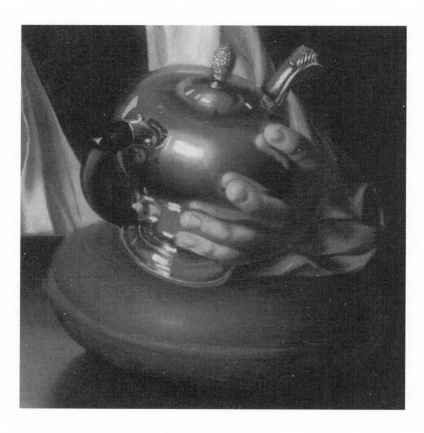

FIGURE 34. Copley, *Paul Revere* (detail).

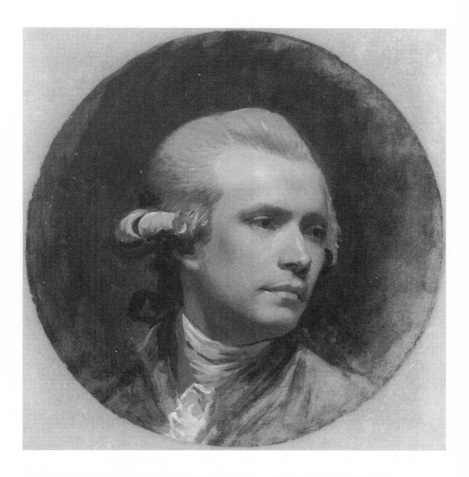

FIGURE 35. John Singleton Copley, *Self-Portrait*, 1780–1784. Oil on canvas, diam. 18 inches. National Portrait Gallery, Smithsonian Institution, Washington, D.C. (NPG 77.22).

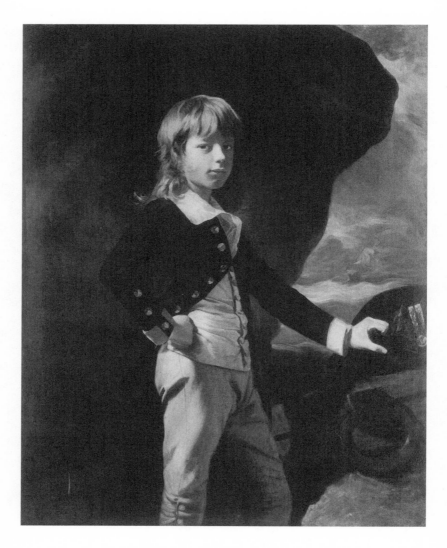

FIGURE 36. John Singleton Copley, *Midshipman Augustus Brine*, 1782. Oil on canvas, 49 1/2 x 39 1/2 inches. The Metropolitan Museum of Art, New York; Bequest of Richard de Wolfe Brixey, 1943 (43.86.4).

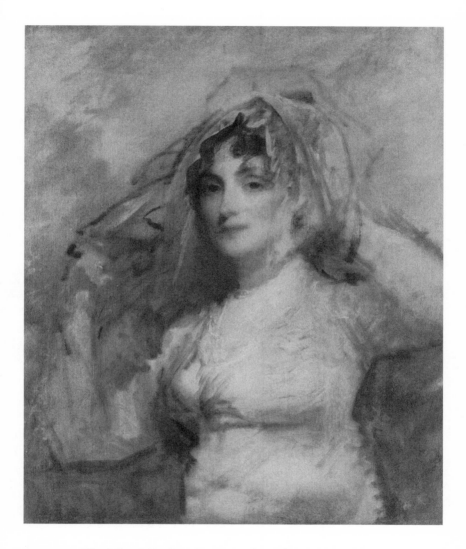

FIGURE 37. Gilbert Stuart, *Mrs. Perez Morton*, ca. 1802. Oil on canvas, 29 1/8 x 24 1/8 inches. Worcester Art Museum, Worcester, Massachusetts; Gift of the grandchildren of Joseph Tuckerman (1899.2).

FIGURE 38. Charles Willson Peale, *Staircase Group (Portrait of Raphaelle Peale and Titian Ramsey Peale)*, 1795. Oil on canvas, 89 1/2 x 39 3/8 inches. The Philadelphia Museum of Art; The George W. Elkins Collection (E'45-1-1).

FIGURE 39. (*Opposite*). Raphaelle Peale, *Venus Rising from the Sea—A Deception (After the Bath)*, ca. 1822. Oil on canvas, 29 1/4 x 24 1/8 inches. The Nelson-Atkins Museum of Art, Kansas City, Missouri; Purchase: Nelson Trust (34-147). Photograph by Robert Newcombe.

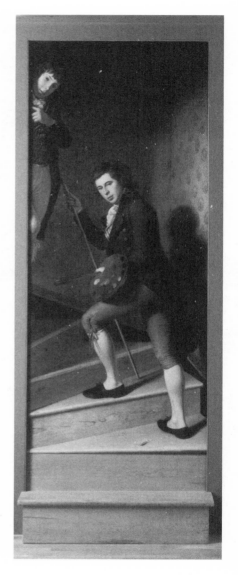

FIGURE 40. Thomas Cole, *Landscape with Tree Trunks*, 1827. Oil on canvas, 26 x 32 1/4 inches. Museum of Art, Rhode Island School of Design, Providence, Rhode Island; Walter H. Kimball Fund.

FIGURE 41. Thomas Cole, *Gnarled Tree Trunk*, ca. 1826. Pen and brown ink over pencil, 14 7/8 x 10 11/16 inches. The Detroit Institute of Arts; Founders Society Purchase, William H. Murphy Fund (39.162). Photograph © 1982 The Detroit Institute of Arts.

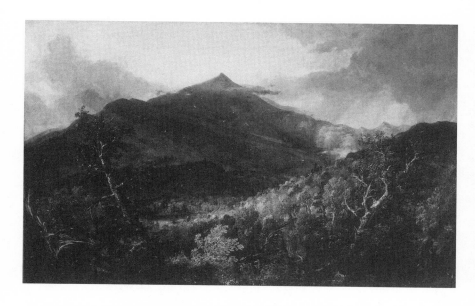

FIGURE 43. Thomas Cole, *View of Schroon Mountain, Essex County, New York, After a Storm*, 1838. Oil on canvas, 39 3/8 x 63 inches. © The Cleveland Museum of Art; The Hinman B. Hurlbut Collection (1335.1917).

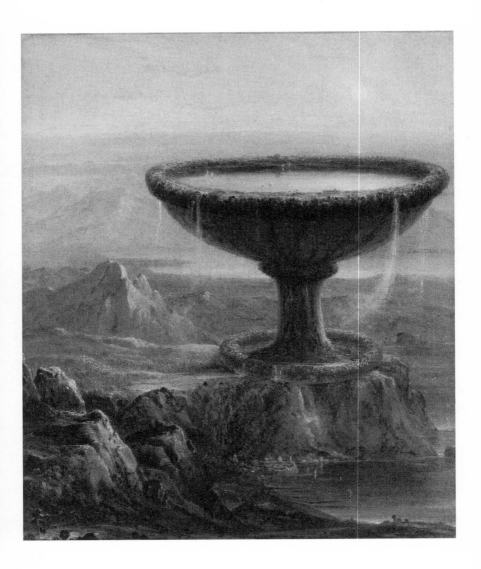

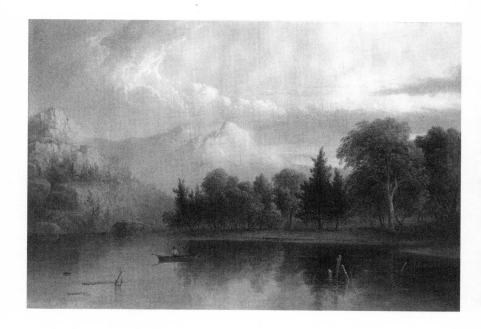

FIGURE 45. Thomas Doughty, *Mountain and Lake*, 1834. Oil on panel, 15 3/4 x 23 inches. Museum of Fine Arts, Boston; Bequest of Maxim Karolik (64.408).

FIGURE 44. (*Opposite*). Thomas Cole, *The Titan's Goblet*, 1833. Oil on canvas, 19 3/8 x 16 1/8 inches. The Metropolitan Museum of Art, New York; Gift of Samuel P. Avery, 1904 (04.29.2).

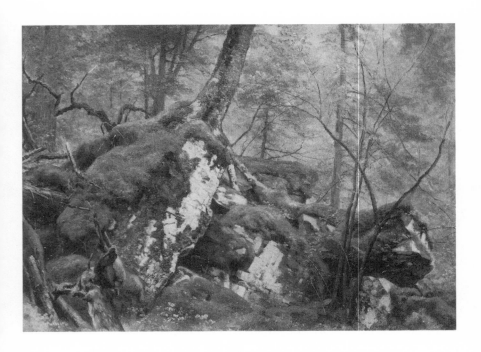

FIGURE 46. Asher Brown Durand, *Interior of a Wood*, ca. 1850. Oil on canvas mounted on panel, 16 3/4 x 24 inches. Addison Gallery of American Art, Andover, Massachusetts; Gift of Mrs. Frederic F. Durand (1932.1).

FIGURE 47. (*Opposite*). Asher Brown Durand, *Group of Trees*, 1855–1857. Oil on canvas, 24 x 18 inches. The New York Historical Society, New York (1887.8).

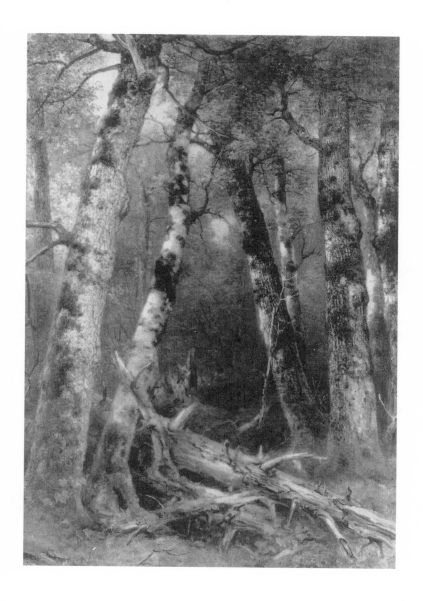

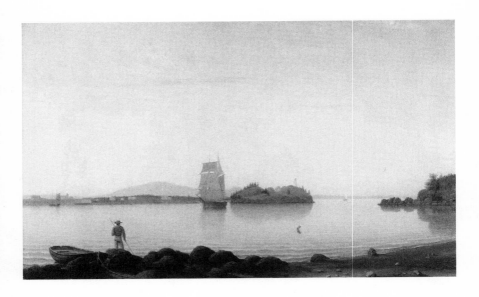

FIGURE 48. Fitz Hugh Lane, *Owl's Head, Penobscot Bay, Maine*, 1862. Oil on canvas, 16 x 26 inches. Museum of Fine Arts, Boston; Bequest of Martha C. Karolik for the M. and M. Karolik Collection, 1815–1865 (48.448).

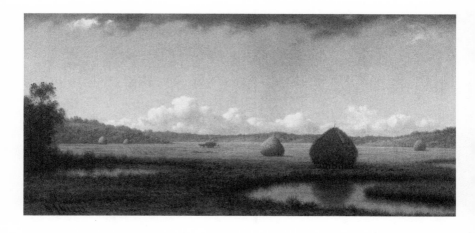

FIGURE 49. Martin Johnson Heade, *Summer Showers*, ca. 1862–1863. Oil on canvas, 13 3/16 x 26 1/4 inches. The Brooklyn Museum; Dick S. Ramsay Fund (47.8).

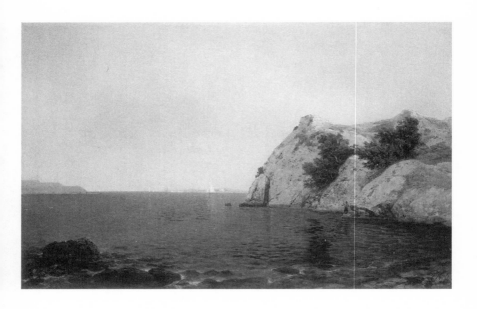

FIGURE 50. John F. Kensett, *Beacon Rock, Newport Harbor*, 1857. Oil on canvas, 22 1/2 x 36 inches. National Gallery of Art, Washington, D.C.; Gift of Frederick Sturges Jr. (1953.1.1).

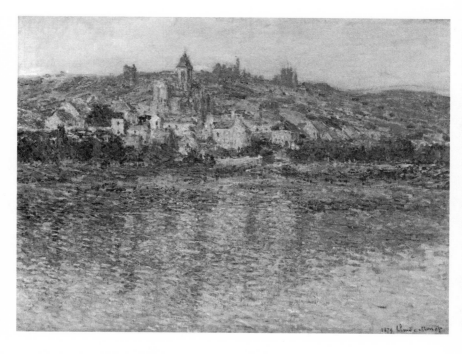

FIGURE 51. Claude Monet, *Vétheuil in Summertime*, 1879. Oil on canvas, 26 5/8 x 35 5/8 inches. Art Gallery of Ontario, Toronto; Purchase (1929.1354).

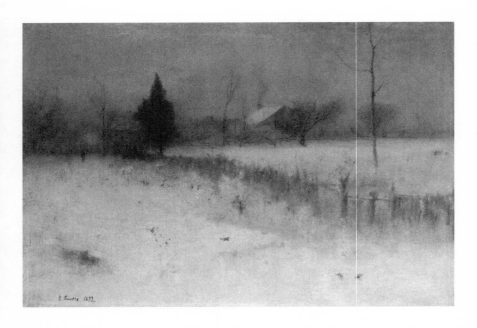

FIGURE 52. George Inness, *Home at Montclair*, 1892. Oil on canvas, 30 1/8 x 45 inches. Sterling and Francine Clark Art Institute, Williamstown, Massachusetts (1955.10).

FIGURE 53. Winslow Homer, *Long Branch, New Jersey*, 1869. Oil on canvas, 16 x 21 3/4 inches. Museum of Fine Arts, Boston; The Hayden Collection—Charles Henry Hayden Fund (41.631).

FIGURE 54. Winslow Homer, *West Point, Prout's Neck*, 1900. Oil on canvas, 30 1/4 x 48 1/4 inches. Sterling and Francine Clark Art Institute, Williamstown, Massachusetts (1955.7).

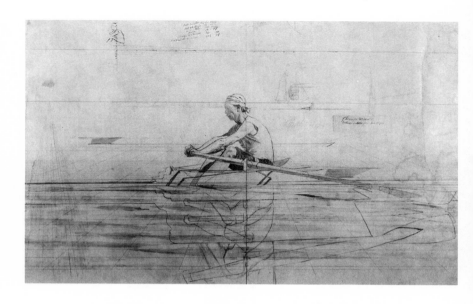

FIGURE 55. Thomas Eakins, *Perspective Studies for "John Biglin in a Single Scull,"* ca. 1873. Graphite pencil, pen, and wash on two sheets of buff paper joined together, 27 3/8 x 45 13/16 inches. Museum of Fine Arts, Boston; Gift of Cornelius V. Whitney (60.1130).

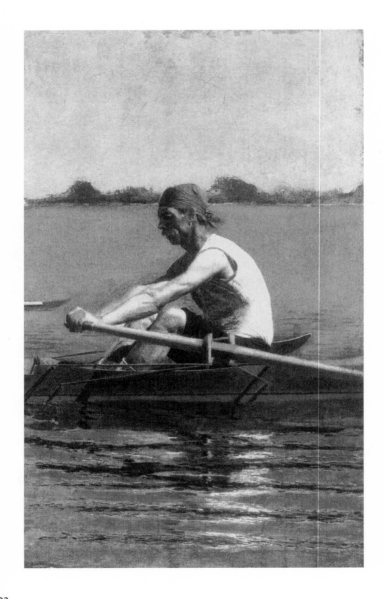

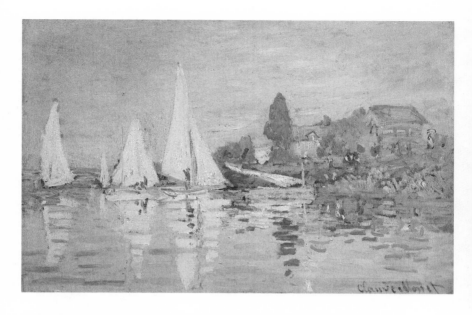

FIGURE 57. Claude Monet, *Regatta at Argenteuil*, 1874. Oil on canvas, 23 1/2 x 39 inches. Musée d'Orsay, Paris (R.F. 2778). Photo: Erich Lessing / Art Resource, New York.

FIGURE 56. (*Opposite*). Thomas Eakins, *John Biglin in a Single Scull*, 1874. Oil on canvas, 24 3/8 x 16 inches. Yale University Art Gallery, New Haven, Connecticut; Whitney Collections of Sporting Art, given in memory of Harry Payne Whitney, B.A. 1894, and Payne Whitney, B.A. 1898, by Francis P. Garvan, B.A. 1897, M.A. (Hon.) 1922 (1932.263).

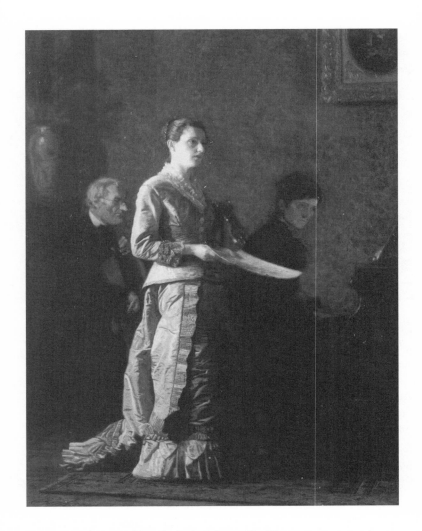

FIGURE 58. Thomas Eakins, *The Pathetic Song*, 1881. Oil on canvas, 45 x 32 1/2 inches. The Corcoran Gallery of Art, Washington, D.C.; Gallery Fund Purchase, 1919 (19.26).

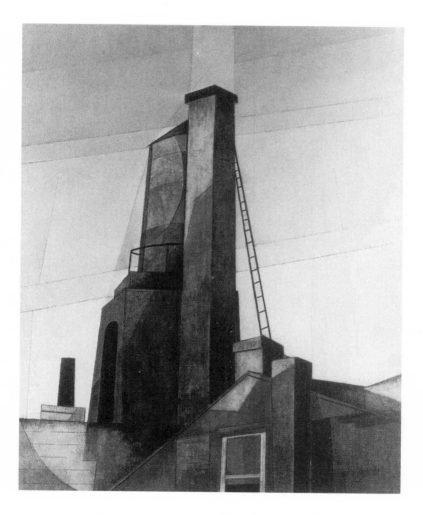

FIGURE 59. Charles Demuth, *Aucassin and Nicolette*, 1921. Oil on canvas, 24 1/8 x 20 inches. Columbus Museum of Art, Columbus, Ohio; Gift of Ferdinand Howald (1931.123).

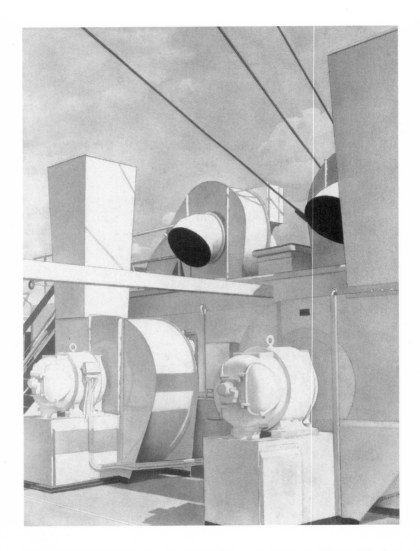

FIGURE 60. Charles Sheeler, *Upper Deck*, 1929. Oil on canvas, 29 1/8 x 22 1/8 inches. Courtesy of the Fogg Art Museum, Harvard University Art Museums, Cambridge, Massachusetts; Louise E. Bettens Fund (1933.97).

FIGURE 61. Marsden Hartley, *Himmel*, ca. 1914–1915. Oil on canvas with original-painting wood border, 47 3/8 x 47 3/8 inches. The Nelson-Atkins Museum of Art, Kansas City, Missouri; Gift of the Friends of Art (56-118). Photograph by Robert Newcombe.

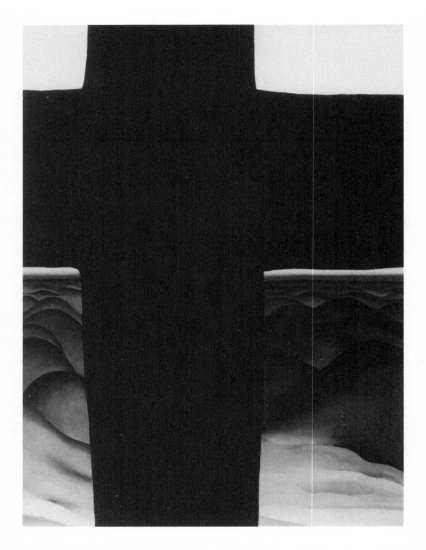

FIGURE 62. Georgia O'Keeffe, *Black Cross, New Mexico*, 1929. Oil on canvas, 39 x 30 inches. The Art Institute of Chicago; Art Institute Purchase Fund (1943.95). © 2003 The Georgia O'Keeffe Foundation / Artists Rights Society (ARS), New York.

The unfriendliness of society to his activity is difficult for the artist to accept. Yet this very hostility can act as a lever for true liberation. Freed from a false sense of security and community, the artist can abandon his plastic bank-book, just as he has abandoned other forms of security. Both the sense of community and of security depend on the familiar. Free of them, transcendental experiences become possible.

Mark Rothko[*]

THREE *Artists of Recognized Standing*

So declared Mark Rothko (1903–1970) in 1947, rehearsing a familiar American lament, but with an optimistic inflection. The precarious situation of art and the artist in America, a theme sounded with regularity throughout our history, is compounded in the twentieth century by the confrontation with modernism. However equivocal the American attitude toward imagery, it did respect a basic realism. The radical challenge to the conventions of representation posed by the European avant-garde assumed extra-aesthetic implications in the years immediately following the Armory Show. The First World War and the Russian Revolution could only encourage an indigenous xenophobia and patriotic self-righteousness, confirming the suspicion that radical art was foreign and morally corrupt, and had no

place in America. The Great Depression following the Crash and the grim political developments in Europe, however, seemed finally to undermine whatever confidence the artists themselves might have had not only in modernism but in the their very profession. The dilemma was declared by Stuart Davis: "In times such as we are living in," he wrote, "few artists can honestly remain aloof, wrapped up in studio problems."[1]

In 1936 these issues found focused, public articulation in the First American Artists' Congress Against War and Fascism. "Through this Congress," Davis announced in the introduction to the published proceedings, "more than 400 leading American artists, academicians and modernists, purists and social realists, were brought together on a platform in defense of their common interests."[2] In a time of crisis stylistic animosities were set aside in favor of shared political, social, and moral concerns. Although the threat of international Fascism set the general tone of the Congress, a manifestation of the Popular Front, the agenda itself was more particularized on domestic issues, dealing with the economic status of the artist as well as his social responsibility. The "Call" for the Congress was addressed

> to all artists, of recognized standing in their profession, who are aware of the critical conditions existing in world culture in general, and in the field of the Arts in particular, . . . to those artists, who, conscious of the need of action, realize the necessity of collective discussion and planning, with the objective of the preservation and development of our cultural heritage. It is for those artists who realize that the cultural crisis is but a reflection of a world economic crisis and not an isolated phenomenon.

Nonetheless, the points enumerated in the proposed agenda primarily addressed the situation of the artist and the arts in America:

> The artists are among those most affected by the world economic crisis. Their income has dwindled dangerously close to zero.
>
> Dealers, museums, and private patrons have long ceased to supply the meager support they once gave.
>
> Government, State and Municipally sponsored Art Projects are giving only temporary employment—to a small fraction of the artists.
>
> In addition to his economic plight, the artist must face a constant attack against his freedom of expression.[3]

The last point in this litany of not unfamiliar complaints alluded to instances in "public and semi-public institutions" in which "suppression, censorship or actual destruction of art works has occurred"—most infamously, Diego Rivera's mural in Rockefeller Center.

A constant theme in the papers of the Congress was the position of the artist in society. Clearly, and especially under current circumstances, artists were no longer aspiring to some exalted level of social prestige. With the suspension of stylistic allegiances, a program of social responsibility determined the thrust of the argument. In a paper entitled "The Artist, His Audience, and Outlook," the painter Max Weber (1881–1961) declared: "The artist functions not only in a spiritual way but also in ways much as a machinist, bricklayer or cobbler does in the industrial sphere." Sounding an old tune in a new key—Copley would have abandoned Beacon Hill all over again—Weber hoped to define a socially useful place for art in the

real world. "But," he had to conclude, "unfortunately art is still considered a luxury meant for the few, the privileged, for those 'favored by destiny.' "[4] Genteel aesthetics had to give way to a sense of proletarian solidarity if the artist was to find his proper place in a society in turmoil. At a second Congress meeting, in 1937, Weber refined his call for

> An art for all,—for men and women who toil and create real wonder and wealth of modern times, and live and hope by the sweat of their brow. Their dreams, their environment, their happiness should be our human concern and artistic inspiration.

And this leads Weber, who had been moved by the Armory Show and whose own gently expressionist style (fig. 63) was formed on European models, to reject the newer manifestations of foreign art in a return to the search for a genuinely American art:

> Conscious searching of the sub-conscious were affectation and pretense, and inevitably leads to impasse and error. What we need today is an American art that will express the Whitmanesque spirit and concept of democracy, an art as heroic and prophetic as the undying *Leaves of Grass* in literature and philosophy of the new world.[5]

We may sense here the kind of discomfort with art that we have observed in earlier periods, the insecurity of its position—and that of its makers—in the world. Moreover, Weber's radical politics notwithstanding, we recognize the nationalist resonance of his aesthetic charge, even its isolationist implications.

Politics and ideology mixed with harsh economic reality in the pronouncements of the First American Artists' Congress, anti-Fascism and condemnation of the European war (until the German invasion of the Soviet Union) with demands for the improvement of the artists' plight. The Federal Art Project of the Work Projects Administration, created in 1935, offered some essential help, in effect recognizing artists as a functioning part of the social economy—or, at least, recognizing their basic economic needs. And yet, this time of looming darkness could hardly provide security. "Artists are always among the first to feel the impact of crisis," Davis declared in the Call for another Congress of American Artists in 1941.

> Our lives and our work are at stake as never before. With the steady decline of the private market and a simultaneous choking off of the government's art program, the economic problem of the artist becomes increasingly acute. Artists find few opportunities for the exercise of their profession and the promise of yesterday is negated in the spreading cultural blackout of today.[6]

The problem of patronage, nothing new in the history of art, assumed a special edge in America. In Europe, even after the revolutions, vestigial structures of institutional patronage remained and were, indeed, reinforced—through the academies and the official salons and exhibitions, part of the establishment of the state. Without the heritage of church or court, America lacked such models; the few major efforts to emulate European example—such as the decoration of the Capitol rotunda or similar projects in state houses—hardly sufficed to establish a pattern. Nor was private patronage any more reliable; wealthy American collectors tended to invest their

capital and their social stock in the purchase of European art. In putting the American artist on a payroll, then, the WPA offered not only a living wage but a public recognition as well. Indeed, out of such official response to the Depression was created a sense of artistic community that had hardly been possible before. As with the American Artists' Congress, stylistic affiliation was less significant than the mere fact of being an artist—"of recognized standing in their profession," as the original Congress call put it.

Such professional recognition, given official sanction by the WPA, was, in effect, communal. To be an artist was to participate in a community, and to be part of a still larger one, of American workers. No longer the bohemian on the fringes of bourgeois society, the artist seemed about to find his place at the center, as producer of a socially valued commodity—notwithstanding the outraged objections of the Hearst press to these "Hobohemian chiselers" on the dole, "ingrates ready to bite the hand that feeds them."[7] The great achievement of the WPA lay not in the work sponsored, but rather in the artistic lives saved, in the maintenance of a generation from which were to emerge some of the genuinely innovative figures in American painting.

The issues of style and standing, however, of the nature of art and the position of the artist in society, could not be so easily separated. Urban disdain for the Regionalist response to the crisis (fig. 64), seen as right-wing chauvinism, could hardly be disguised. Nor could suspicion of abstraction as precious, as aesthetic self-indulgence, be suppressed (fig. 65). At the Congress session on "The Artist in Society," Meyer Schapiro set out "to show how the social basis operates even within an art that seems to be an entirely independent art."[8] His opening words articulate the dilemma with proleptic clarity:

When we speak in this paper of the social bases of art we do not mean to reduce art to economics or sociology or politics. Art has its own conditions which distinguish it from other activities. It operates with its own special materials and according to general psychological laws.

Nonetheless, Schapiro insisted on the very real connection between art and the social world in which it is created, between the modern artist and his bourgeois patrons; he observed the power of the modern patron to co-opt the values of the artist, and above all his sense of freedom. In that very freedom, however, in that supposed repudiation of bourgeois "moral standards and responsibilities," Schapiro located the self-delusion of the modern artist and his moral and political failure:

> Since he attributes his difficulties, not to particular historical conditions, but to society and human nature as such, he has only a vague idea that things might be different than they are; his antagonism suggests to him no effective action, and he shuns the common slogans of reform or revolution as possible halters on his personal freedom.

In describing the situation of the artist and its ambivalence, Schapiro participated in the dilemma itself, at once celebrating the inventive freedom of the artist and deploring his withdrawal from social action:

> Yet helpless as he is to act on the world, he shows in his art an astonishing ingenuity and joy in transforming the shapes of familiar

things. This plastic freedom should not be considered in itself an evidence of the artist's positive will to change society or a reflection of real transforming movements in the everyday world.

The participants in the First American Artists' Congress were rehearsing the conflict between the rival claims of art and social conscience that was to be effectively resolved only in the following year, on a monumental pictorial scale, in Picasso's *Guernica*—which the group was instrumental in bringing to New York. American artists, however, could not easily bring the pictorial language of modernism to bear on the pressing issues of the real world. That language was not theirs to use with such native fluency and expressive confidence. Commenting on the social realism, verging on caricature, that seemed the more natural mode of pictorial response to political and social concerns in this country, the abstract painter George L. K. Morris (1905–1975) lamented the unfortunate impact of such a charge "upon artists who have never become grounded in an authentic tradition of their own."[9] Stylistic insecurity undermined the effort of the American artist to find eloquent voice in a time of crisis. Art for the millions may have been the goal of the supporters of the WPA, but, as one beneficiary of the federal program put it, the project tended to yield "poor art for poor people."[10]

Even as they had to define themselves within the situation of art in America, so too did American artists feel obliged to distance themselves from the acknowledged masters of European modernism. Again, the essential insecurity of painting in America exacerbated the dilemma of the artist: rendering "the American scene" by using "some of the methods of modern French painting," as Davis put it (see fig. 24 above). The artist had to find his own pictorial language

without the support of aesthetic axiom, without basic, shared assumptions regarding the functions and operations of art. The modern American painter—like Copley two centuries earlier—had "to start from scratch, to paint as if painting never existed before," as Barnett Newman was to recall the situation years later.[11] And inventing his art meant for the painter inventing himself.

Stylistic insecurity was one manifestation of the larger professional dilemma, the question of what it meant to be an artist in America. The early careers of two immigrants exemplify the situation in interesting ways; they play out the artist's search for professional identity in America with special clarity and personal drama. Arshile Gorky (1900–1948), who worked in the mural division of the Federal Art Project—and is the author of the quip about "poor art for poor people"—loudly walked out on another group, the American Abstract Artists, taking with him his fellow immigrant, Willem de Kooning (1904–1997).[12] These two nonjoiners were to become leading protagonists in painting's triumph in America, and their careers serve to refine the question of professional identity, redirecting it more urgently toward the self, in which they—like their American-born comrades of a new generation—discovered a more authentic subject for painting.

Gorky was born in Turkish Armenia sometime around 1900, baptized Vosdanik Manoog Adoian, and he lived through terrible years of upheaval, repression, and wandering before arriving finally in America in 1920. Five years later he was in New York, a gifted student and soon to be instructor at the Grand Central School of Art, rebaptized with a name of his own invention. Adopted from the also self-named Russian writer, the new name is accompanied by an appropriate family romance: the young immigrant painter declares

himself the cousin of the renowned Russian author Maxim. With enviable efficiency, Gorky took a first, radical step toward resolving the problem of the artist's identity, naming himself to fame and success.

More to the point, his career as an artist follows a similar pattern of self-invention. Gorky's search for a style of his own led him through a recapitulation of modern art as he tried on different artistic personae—Cézanne, Picasso, Miró, Kandinsky—until he became "himself" (fig. 66). "I was with Cézanne for a long time," he explained, "then naturally I was with Picasso."[13] That search is really quite different from the style and role-playing of Picasso, who created his own possibilities and for whom such shifts were an integral part of his conception of his art and of himself. As he had invented a new name and biography for himself, Gorky tested himself as other in his painting. Without a style properly his own, he sought one by mimicking the history of pictorial modernism, a trajectory leading him to his own moment in the sequence—as though the momentum would assure his own place in that history. More than most artists in America—by now we should say in New York—the immigrant was professionally without roots, but, as had Copley, he knew to focus his vision back toward Europe, toward the culture that acknowledged modern masters of art.

For Gorky there was no question of what art was about: it was about being an artist. Through art he would discover, or create, his own identity. His early work comprises many portraits of himself and of his family, heads identified as his sister, Vartoosh, or, more interestingly, called "Portrait of Myself and My Imaginary Wife" (fig. 67). This double image is signed "A. Gorky" and dated "23." Many of Gorky's early paintings were reworked over a period of years, and the continuing difficulty in establishing a secure chronology for his

work is exacerbated in this case by the likelihood that the artist returned to the picture sometime later to sign it, dating it retroactively to his nineteenth year (according to his calculation) and thereby suggesting a certain precocity.[14] The entire painting seems a product of fantasy, of identity crisis. The so-called self-portrait is an exercise in a pre-Cubist Picasso mode, and such a model tests its verisimilar credentials. The title assigned to the female head ostensibly denies whatever reference to reality the representation itself may pretend. It is, however, the assertion of the title that claims our attention, the invention—at whatever age—of an imaginary family construct. The title, as well as the domestic assembly, of a later drawing, of 1939, further testifies to the artist's reparative agenda: "Family Dream Figures" (fig. 68).

As he brooded over his identity, the painter studied himself, as a preadolescent, standing alongside his mother in an old photograph (fig. 69). Gorky evidently spent some ten years (ca. 1926–1936) on several portraits (fig. 70)—large paintings of himself with his mother, as well as separate drawings of each—trying to sort out and reconcile the tenses of his life. In the course of getting to know himself and the mother he lost when he was fifteen (according to his reckoning), he clarified an approach to form, an attitude toward line and edge, that was to become an essential component of his own style—however much inspired by and indebted to the older masters he had mimicked. Neither of the two canvases he produced (the one not illustrated here is in the National Gallery of Art) was, in a strictly technical sense, ever finished. The surfaces remain scumbled in part, and the hands in particular seem almost deliberately unrealized. (The curious reluctance to render hands is a feature of many of Gorky's figural works, a feature he shares with de Kooning.) Only the intensely stud-

ied, iconic faces are brought to full life. Totally ignored in Gorky's various renditions of the image is one motif in the photograph, its most blatantly pictorial: the floral pattern of his mother's dress. Years later he returned to that suppressed pattern, recalling it explicitly in the title of a fully mature painting of 1944: "How My Mother's Embroidered Apron Unfolds in My Life" (fig. 71).

Out of the recollections, real and imagined, of his Armenian childhood—transforming his father's garden with its holy tree, identified as "the Garden of Wish Fulfillment," into the series of canvases of the *Garden in Sochi* (figs. 72, 73)—Gorky created an iconography of the self.[15] And the fantasy that drew upon realities from the distant personal past mixed such remembrances with the more immediate experiences of America—landscapes, interiors, still-life, plants and petals. The surfaces of his paintings—fluidly shifting planes of brushed color and chromatic stain, lines of tensile grace and insectile strength, culminating in forms of suggestive precision—breathe an exotic sensuality. Formal structures, moving on and notionally beyond the surface, establish an organically founded perspective; pictorial space is open—recalling, even, that "breathable atmosphere through which we are conscious of spaces and distances" urged on painting by Inness.

Gorky's titles are as evocative as his surfaces. Both invite imaginative projection into realms of lived experience that—despite their hermetic lyricism, confessional suggestion, and occasional Surrealist gesture—are fundamentally accessible: *Water of the Flowery Mill, The Liver Is the Cock's Comb, Landscape Table, The Calendars, Days, Etc., The Betrothal* (fig. 74), *The Diary of a Seducer, Charred Beloved, Agony, The Limit, The Plow and the Song.* The titles themselves imply eventful biography, the emotional experiences and crises of a life, as

well as a certain poetic fantasy. We would find them moving even without our knowledge of Gorky's troubled years and final suicide in 1948.

Gorky's achievement was to have found not only the formal means but also an authentic subject matter for his art. Unlike his older contemporaries, including his friend and mentor Stuart Davis, he did not look to a public world for that content. Whatever his personal insecurity, he had absolute confidence in art, in the modernism of the masters he came to know so well through emulation and from whose styles he manufactured his own, as well as in the tools of his craft—he loved a fine brush. And in creating a style for himself he triumphed over that insecurity; by making an art of his own he found new substance for the borrowed masks. Perhaps no other painter in America had assigned such personal significance to art, had risked so much on it.

Following Gorky as he walked out of the meeting of the American Abstract Artists was his friend Willem de Kooning. These two had much in common: both were immigrants, de Kooning having come from Rotterdam in 1926; both worked in the mural division of the Federal Arts Project, although, as a noncitizen, de Kooning was forced to resign; both looked to European modernism for inspiration, and both were close to the legendary John Graham (1881–1961), the most extravagant and ambitious of self-made vanguard personalities. Unlike Gorky, however, de Kooning arrived in this country already an independent young man, with substantial technical training. In New York he supported himself by working as a house painter, commercial artist, display designer, and carpenter; his serious painting remained a sideline. De Kooning's one year with the WPA changed all that. "The year I was on," he later recalled, "gave me such

a terrific feeling that I gave up painting on the side and took a different attitude. After the project I decided to paint and to do odd jobs on the side. The situation was the same, but I had a different attitude."[16] What the WPA gave de Kooning was a taste of professionalism, a sense of what it meant to call oneself an artist.

Although deeply involved in the art world of New York and fully aware of the crisis of the times, neither Gorky nor de Kooning was particularly engaged politically; despite their friendship with Stuart Davis, neither signed the Call in 1936—possibly because neither was yet an artist of sufficiently "recognized standing in their profession." Both remained "wrapped up in studio problems," and in their work both displayed that "astonishing ingenuity and joy in transforming the shapes of familiar things" that Meyer Schapiro so ambivalently celebrated in his paper for the Congress. Their focus was on making art and making themselves artists.

Like Gorky, de Kooning shifted his attention between abstraction and representation, moving easily between the two modes. His abstract designs of the thirties, exercises in modernism, are marked by a structure combining tectonic and biomorphic shapes and by a clarity of color (fig. 75). His more overtly representational images, generally of clothed male figures, standing or seated, feature a more somber palette, monochromatic fields of brown and gray relieved by inflections of pink and green (fig. 76). In these de Kooning seems to be participating in the moral deadpan of social realism, a joyless chromatic neutrality. The baggy pants and rumpled jackets of his figures bear witness to the economic reality as well as fashion of the decade. Some of these figures are portraits of friends; others, with their large penetrating eyes, reflect the face of the artist himself, as well as his own clothes:

I took my trousers, my work clothes. I made a mixture out of glue and water, dipped the pants in and dried in front of the heater, and then of course I had to get out of them. I took them off—the pants looked pathetic. I was so moved, I saw myself standing there. I felt so sorry for myself. Then I found a pair of shoes—from an excavation—they were covered with concrete, and put them under it. It looked so tragic that I was overcome with self-pity. Then I put on a jacket and gloves. I made a little plaster head. I made drawings from it and had it for years in my studio. I finally threw it away. There's a point when you say enough is enough.[17]

However screened, the recollection testifies to a deeply felt participation in the pathos of the Depression. De Kooning's figures are personalized representatives of a particular moment in our culture—as much as any by, for example, Raphael Soyer (1899–1987) (fig. 77). But his essential response, displaced, is to himself. If not as incessantly as Gorky, de Kooning too drew and painted his own image; he too created himself through his art. There is perhaps no more moving document of this than the drawing called "Self-Portrait with Imaginary Brother," which the artist acknowledged to be a double portrait (fig. 78) (and which, not incidentally, was owned by Saul Steinberg, an artist for whom self-identity was indeed a major theme). We need not rehearse de Kooning's biography—his parents' divorce when he was five; the court's assignment of the young boy to the father, his sister to the mother; the mother's appeal and reclamation of the boy. We don't need such biographical data to acknowledge the poignancy of such a drawing: the imaging of a younger self and the imagining of a sibling, the graphic fabrication of a family bond,

the use of art to create a life. "All that we can hope for," as he said, "is to put some order into ourselves."[18]

Self-portraiture in itself is hardly remarkable. Many artists, especially young artists, turn to their own faces as subjects of investigation. No one more than Picasso has made art into biography, actual and fictional, surrounding himself with invented family, making himself the substance of his art. What distinguishes the American situation, as I have been suggesting, is the social and professional condition under which these images of the self are produced, the condition of the artist and of art, the counterclaims of an external world in crisis for which "studio problems" can only represent social irresponsibility, pure solipsism. Gorky's devotion to an old photograph, his invention of family romances, his search for a self in and through his art—all this assumes a particular urgency under these circumstances, as does his stylistic recapitulation of the masters. De Kooning's explorations may seem, in comparison, less desperate. And yet the dynamics are not so different. Rootless, he too sought to establish identity in and through his art, which meant taking art very seriously indeed. Their common dedication to the materials of painting, their appreciation of its craft, the sheer professionalism of their concern with "studio problems" further distinguish these two painters from many of their American contemporaries. And yet their special strengths, the willfulness of their application and the determination of their programs, derive as well from the conditions of art in America. The open situation of the thirties, a period in which the very existence of art in society seemed subject to question, provided an environment in which searching talent could discover, or create, its self.

The realities of the thirties provided a strangely fertile ground for this younger generation of developing artists. Few of them were

attracted to the official modernism of academic abstraction, a geometric formalism very much "wrapped up in studio problems." They would have felt more sympathy for the overt seriousness of representational painting, its social and personal commitment, its apparently more obvious opportunities for expression through narrative or suggestive anecdote and somber tone. The intimate scale of their easel paintings assures the personal voice of that expression. The young Jackson Pollock's (1912–1956) lingering regionalism (fig. 79), legacy of his teacher, Thomas Hart Benton (fig. 80), shares more with the private romanticism of Albert Pinkham Ryder (1847–1917) (fig. 81) ("the only American master who interests me") than with the public ambition of WPA murals; we recognize the personal rhythms and energies of the artist already in the early landscapes of Depression America. And Mark Rothko's early urban interiors and subway scenes, by their own formal or chromatic self-awareness, insist on transforming prosaic themes into a more personal poetry (fig. 82). In the common social subject matter, then, these artists deliberately sought something more individual, something uniquely their own. From the democratic iconography of the 1930s they tried to wrest an imagery that would represent themselves. It is hardly without significance that among the most compelling of Rothko's early works, proleptic in its structure, is a self-portrait, a direct confrontation of the painter with his image—and his art (fig. 83).

To find an individual pictorial voice within the chorus of such common thematic material proved a crucial challenge. But if the subject matter of the thirties offered the opportunity to develop technical means as well as to test expressive possibilities, such "interpretations of the environment," however "intellectual and emotional," failed ultimately to satisfy the need for a subject matter that is "tragic and

timeless." The "protest against the reputed equivalence of American painting and literal painting"[19] led inexorably beyond the visible truisms of social realism and regionalism, beyond the personalized facture of expressionist technique.

The struggle developed on two fronts: one against the provincialism of American aesthetic values and conventional assumptions about art; the other, more complex, against the very modernism that seemed to offer the antidote to that provincialism. In either case, the challenge was defined in essentially local terms. The issues found summary articulation in the pamphlet of "The Whitney Dissenters," ten artists, Adolph Gottlieb (1903–1974) and Rothko among them, who protested the conservative values of the museum and refused to exhibit in the Annual of 1938:

> A public which has had "contemporary American art" dogmatically defined for it by museums as a representational art preoccupied with local color has a conception of an art only provincially American and contemporary only in the strictly chronological sense. This is aggravated by a curiously restricted chauvinism which condemns the occasional influence of the cubist and abstractionist innovators while accepting or ignoring the obvious imitations of Titian, Degas, Breughel and Chardin.[20]

What indeed did it mean to create art in America in the twentieth century? Surely more than portraying the American scene according to realist conventions that had been rendered irrelevant by modernist revolutions or, toward the same end, by enlisting modernist models. However much they may have owed to the example of "the cubist and abstractionist innovators," whatever pictorial eloquence they may

have learned from them, these American painters could hardly find their own voices in such foreign languages. "I am an American, born in Philadelphia of American stock": we recall Stuart Davis's proud pledge of aesthetic patriotism—even as he admitted the "influence" of Matisse and Picasso. "I studied art in America. I paint what I see in America, in other words, I paint the American scene."

The social commitment of the thirties, with its profoundly personal dimension, provided a kind of ethical base for the continuing search for a genuinely American art. Whatever painting was, it carried responsibility: it was expected to be a significant as well as a signifying activity, to make a serious statement of genuine import. The rejection of the notion of art as "a luxury meant for the few, the privileged" (Weber), the impatience with artists "wrapped up in studio problems" (Davis)—such ethical imperative continued to inform the younger generation in its search for an art of meaning, for pictures that "have significance." The goal was articulated in the much-cited letter of June 7, 1943, to Edward Alden Jewell, art critic of the *New York Times*, signed by Adolph Gottlieb and Marcus Rothko, drafted in collaboration with Barnett Newman (1905–1970). Responding to the "befuddlement" of the critic before their pictures, but refusing to defend or explain them, the painters enumerated the "aesthetic beliefs" informing their work:

1. To us art is an adventure into an unknown world, which can be explored only by those willing to take risks.
2. This world of the imagination is fancy-free and violently opposed to common sense.
3. It is our function as artists to make the spectator see the world our way—not his way.

4. We favor the simple expression of the complex thought. We are for the large shape because it has the impact of the unequivocal. We wish to reassert the picture plane. We are for flat forms because they destroy illusion and reveal truth.

5. It is a widely accepted notion among painters that it does not matter what one paints as long as it is well painted. This is the essence of academicism. There is no such thing as good painting about nothing. We assert that the subject is crucial and only that subject matter is valid which is tragic and timeless. That is why we profess spiritual kinship with primitive and archaic art.[21]

These painters turned away from the external world of realism to the realm of myth for their subjects. To the large shapes of their paintings they gave titles like "Sacrifice," "Eyes of Oedipus," "Orpheus," "Leda," "The Syrian Bull," "The Omen of the Eagle" (fig. 84)—insisting, however, "that this is not mythology out of Bullfinch. The implications here," Gottlieb explained in a radio dialogue of the same year, "have direct applications to life, and if the presentation seems strange, one could without exaggeration make a similar comment on the life of our time."[22]

If myth afforded a way of confronting a harsh contemporary reality, it also offered a way of participating in a larger human experience. More profoundly than WPA maintenance, it served to define the artist, to locate him and to justify his activity as image maker, rooting it in a universal humanity. Myth offered a justification of painting itself. In so-called primitive art was to be found a natural language of expression.

Jackson Pollock, in an interview in 1944, praised "the plastic qualities of American Indian art. The Indians," he explained, "have the true

painter's approach in their capacity to get hold of appropriate images, and in their understanding of what constitutes painterly subject-matter. . . . their vision has the basic universality of all real art."[23] And, three years later, in the preface to the group show "The Ideographic Picture," Barnett Newman invoked the Kwakiutl artist as exemplum:

> The abstract shape he used, his entire plastic language was directed by a ritualistic will towards metaphysical understanding. . . . To him a shape was a living thing, a vehicle for an abstract thought-complex, a carrier of the awesome feelings he felt before the terror of the unknowable. The abstract shape was, therefore, real rather than a formal "abstraction" of a visual fact, with its overtone of an already-known nature.[24]

Speaking of and for his generation, Newman could declare: "Spontaneous, and emerging from several points, there has arisen during the war years a new force in American painting that is the modern counterpart of the primitive impulse."

Through the modernism of twentieth-century Paris, the American artist discovered the primitive roots of his vocation. The very legitimacy of his activity was confirmed by the subjects of his art. Titling, or not titling, assumed special importance in asserting kinship with "the primitive impulse." Newman's own titular primitivism was more cosmological than anthropological: "Gea" (1945), "The Beginning" (1946), "Pagan Void" (1946), "Genetic Moment" (1947). Titles like "Euclidean Abyss" (1946–1947) (fig. 85) and "Death of Euclid" (1947) celebrate what he called "the chaos of pure fantasy and feeling," that which distinguishes the new American painters from the European modernists with "their base in sensual nature."

Pollock's titles of the early forties are more overtly referential and figural, evoking elemental values implicit in the mythological constructs of the American Indian. His show at Peggy Guggenheim's Art of This Century gallery in 1943 featured, for example, "Wounded Animal," "She-Wolf," "Moon-Woman," "Guardians of the Secret" (fig. 86). Clement Greenberg responded enthusiastically to these "not so abstract abstractions," finding them "among the strongest abstract paintings yet seen by an American," but parenthetically he pronounced Pollock's titles "pretentious."[25] Greenberg's review was both sympathetic and prescient, but the critic may have had more confidence than the painter at this moment in his career. Although generally assigned post facto, reactively, titles were part of the expressive effort; they represented an extension of the artist's gesture and served as indices of response and interpretation. Titles affirmed that "subject is crucial"—and, therefore, that painting itself had meaning.

In 1948 a group of artists—Robert Motherwell (1915–1991), Mark Rothko, William Baziotes (1912–1963), and David Hare (1917–1992)—founded a new art school. Although it lasted only a year, the school's name resonantly proclaimed the central concern of this generation: "The Subjects of the Artist."[26] Titles do count; subject is crucial.

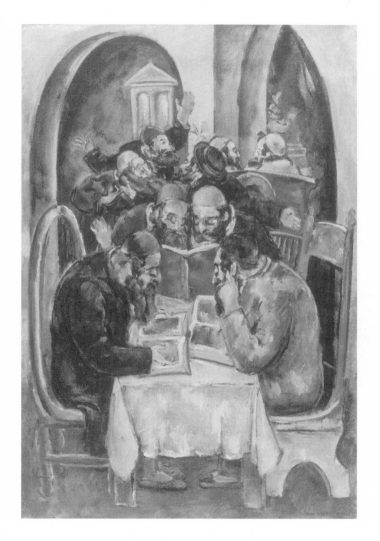

FIGURE 63. Max Weber, *The Talmudists*, 1934. Oil on canvas, 50 x 33 3/4 inches. The Jewish Museum, New York; Gift of Mrs. Nathan Miller. Photo: The Jewish Museum / Art Resource, New York.

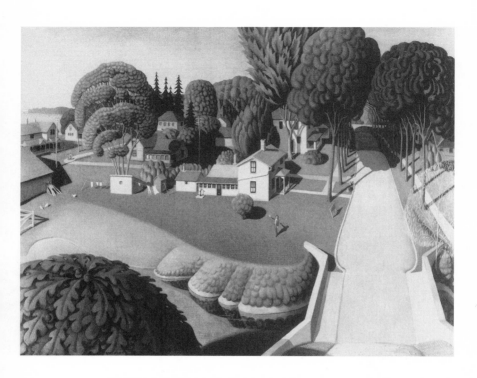

FIGURE 64. Grant Wood, *The Birthplace of Herbert Hoover*, 1931. Oil on masonite, 30 x 40 inches. Des Moines Art Center Permanent Collections; Purchased jointly by the Des Moines Art Center and The Minneapolis Institute of Arts with funds from Mrs. Howard H. Frank, the Edmundson Art Foundation, Inc., and the John R. Van Derlip Fund (1982.2). © Estate of Grant Wood / Licensed by VAGA, New York, New York.

FIGURE 65. George L. K. Morris, *Concretion 1*, 1936. Oil on canvas, 14 x 18 1/4 inches. Private collection, New Jersey. Courtesy Gary Snyder Fine Art, New York.

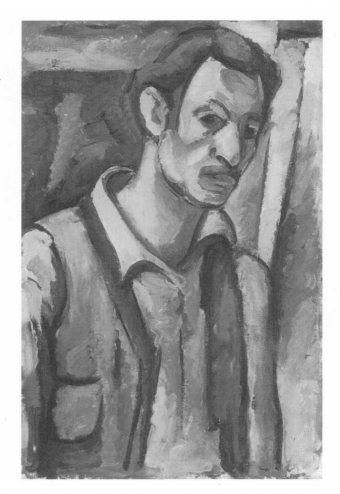

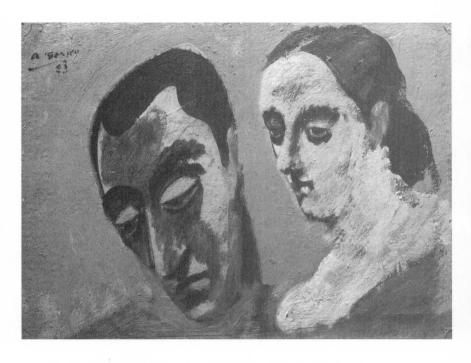

FIGURE 67. Arshile Gorky, *Portrait of Myself and My Imaginary Wife*, 1923. Oil on cardboard, 8 1/2 x 14 1/4 inches. Hirshhorn Museum and Sculpture Garden, Smithsonian Institution, Washington, D.C. © 2003 Agnes Gorky Fielding / Artists Rights Society (ARS), New York.

FIGURE 68. Arshile Gorky, *Family Dream Figures*, ca. 1939. Pen and ink on paper, 8 13/16 x 6 11/16 inches. Private collection.

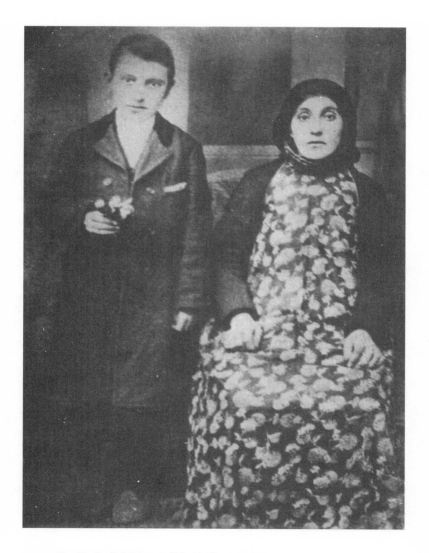

FIGURE 69. *Vosdanik Adoian and His Mother, Van City,* 1912.

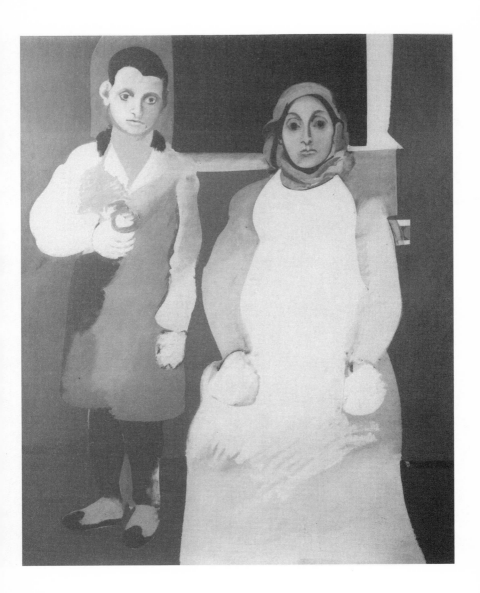

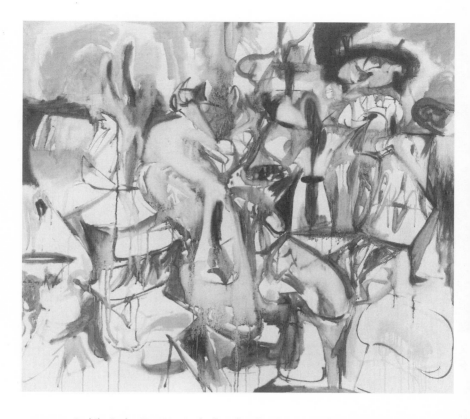

FIGURE 71. Arshile Gorky, *How My Mother's Embroidered Apron Unfolds in My Life*, 1944. Oil on canvas, 40 x 45 1/16 inches. Seattle Art Museum, Seattle; Gift of Mr. and Mrs. Bagley Wright. © 2003 Agnes Gorky Fielding / Artists Rights Society (ARS), New York.

FIGURE 70. (*Opposite*). Arshile Gorky, *The Artist with His Mother*, 1926–1929/36(?). Oil on canvas, 60 x 50 inches. Whitney Museum of American Art, New York; Gift of Julien Levy for Maro and Natasha Gorky in memory of their father (50.17). © 2003 Agnes Gorky Fielding / Artists Rights Society (ARS), New York.

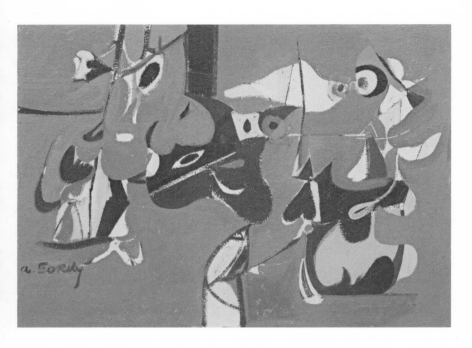

FIGURE 72. Arshile Gorky, *Garden in Sochi*, 1941. Oil on canvas, 44 1/4 x 62 1/4 inches. The Museum of Modern Art, New York; Purchase Fund and Gift of Mr. and Mrs. Wolfgang S. Schwabacher (by exchange) (335.1942). © 2003 Agnes Gorky Fielding / Artists Rights Society (ARS), New York. Digital image © The Museum of Modern Art / Licensed by SCALA / Art Resource, New York.

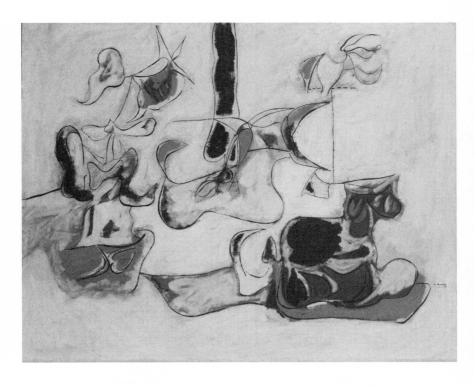

FIGURE 73. Arshile Gorky, *Garden in Sochi*, ca. 1943. Oil on canvas, 31 x 39 inches. The Museum of Modern Art, New York; acquired through the Lillie P. Bliss Bequest (492.1969). © 2003 Agnes Gorky Fielding / Artists Rights Society (ARS), New York. Digital image © The Museum of Modern Art / Licensed by SCALA / Art Resource, New York.

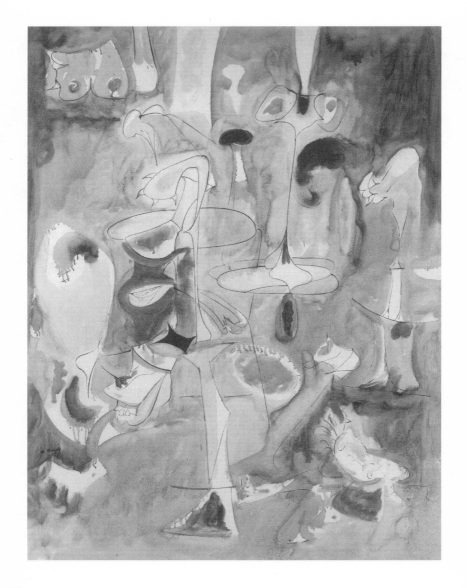

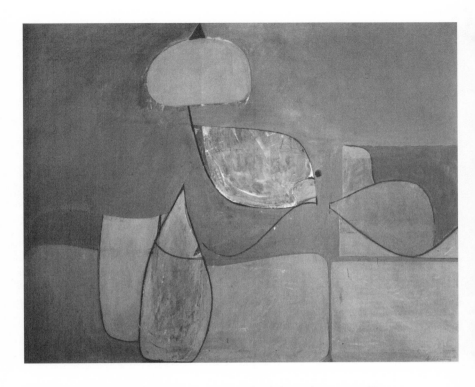

FIGURE 75. Willem de Kooning, *Elegy*, ca. 1939. Oil and charcoal on composition board, 40 1/4 x 47 7/8 inches. Private collection. © 2003 The Willem de Kooning Foundation / Artists Rights Society (ARS), New York.

FIGURE 74. (*Opposite*). Arshile Gorky, *The Betrothal*, 1947. Oil on canvas, 50 5/8 x 39 1/4 inches. Yale University Art Gallery, New Haven, Connecticut; The Katherine Ordway Collection (1980.12.45). © 2003 Agnes Gorky Fielding / Artists Rights Society (ARS), New York.

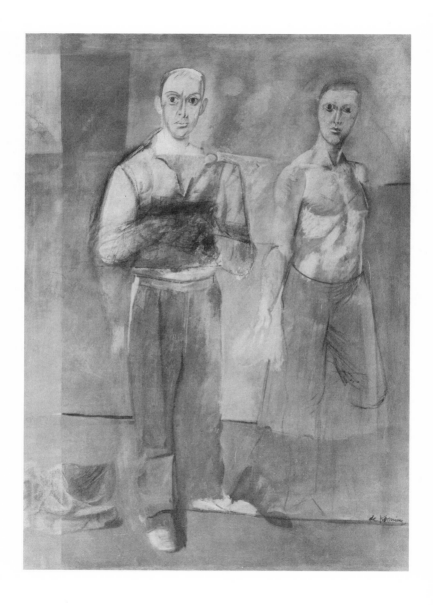

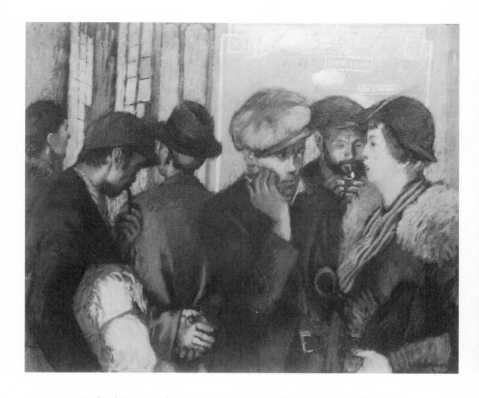

FIGURE 77. Raphael Soyer, *Sixth Avenue*, ca. 1933–1934. Oil on canvas, 26 1/8 x 32 1/8 inches. The Wadsworth Atheneum, Hartford, Connecticut; Gift of Mr. and Mrs. James N. Rosenberg (1947.18).

FIGURE 76. (*Opposite*). Willem de Kooning, *Two Men Standing*, ca. 1938. Oil on canvas, 61 1/8 x 45 1/8 inches. The Metropolitan Museum of Art, New York; from the Collection of Thomas B. Hess, Purchase Rogers, Louise V. Bell, and Harris Brisbane Dick Funds, and Joseph Pulitzer Bequest, 1984 (1984.612). © 2003 The Willem de Kooning Foundation / Artists Rights Society (ARS), New York.

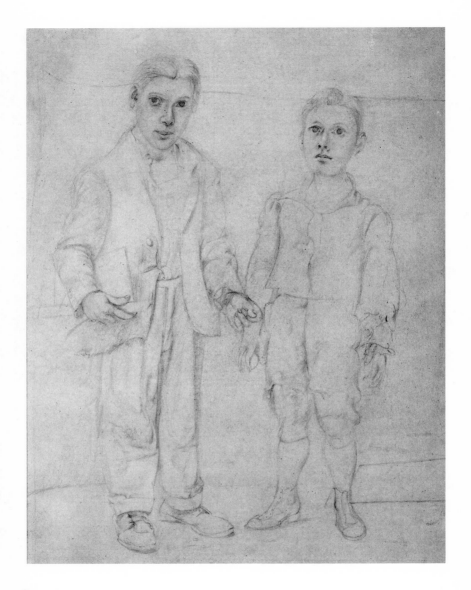

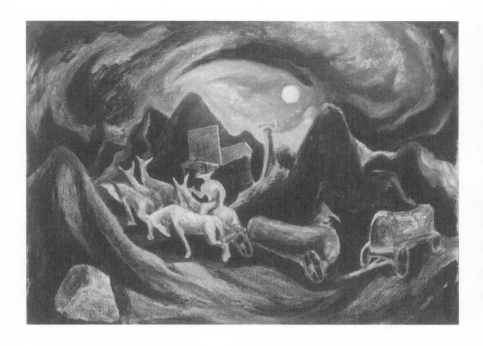

FIGURE 79. Jackson Pollock, *Going West*, ca. 1934–1938. Oil on fiberboard, 15 1/8 x 20 3/4 inches. National Museum of American Art, Smithsonian Institution, Washington, D.C.; Gift of Thomas Hart Benton. © 2003 The Pollock-Krasner Foundation / Artists Rights Society (ARS), New York. Photo: Art Resource, New York.

FIGURE 78. (*Opposite*). Willem de Kooning, *Self-Portrait with Imaginary Brother*, ca. 1938. Pencil on paper, 13 1/8 x 10 5/16 inches. Courtesy Matthew Marks Gallery, New York. © 2003 The Willem de Kooning Foundation / Artists Rights Society (ARS), New York.

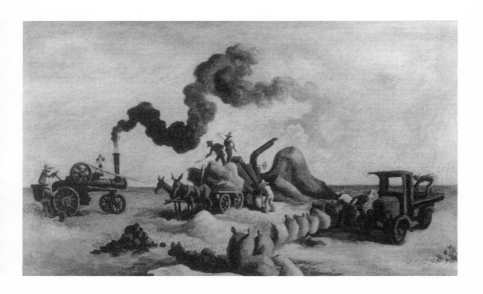

FIGURE 80. Thomas Hart Benton, *Louisiana Rice Fields*, 1928. Egg tempera and oil on masonite, 30 1/8 x 47 7/8 inches. Brooklyn Museum; John B. Wood Memorial Fund (38.79). © T. H. Benton and R. P. Benton Testamentary Trusts / Licensed by VAGA, New York, New York.

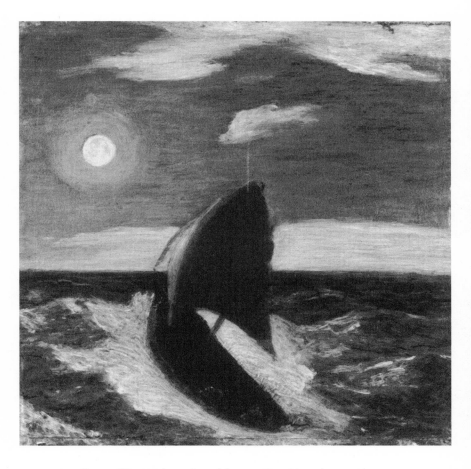

FIGURE 81. Albert Pinkham Ryder, *Toilers of the Sea*, 1883–1884. Oil on panel, 11 1/2 x 12 inches. The Metropolitan Museum of Art, New York; George A. Hearn Fund, 1915 (15.32).

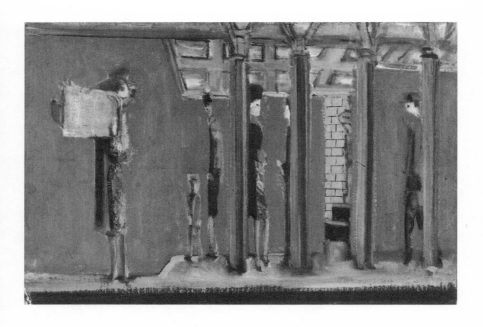

FIGURE 82. Mark Rothko, *Subway*, 1930s. Oil on canvas, 34 5/16 x 46 1/2 inches. National Gallery of Art, Washington, D.C.; Gift of The Mark Rothko Foundation, Inc. (3261.30). © 1998 Kate Rothko Prizel and Christopher Rothko / Artists Rights Society (ARS), New York.

FIGURE 83. (*Opposite*). Mark Rothko, *Self-Portrait*, 1936. Oil on canvas, 32 1/2 x 26 inches. Christopher Rothko and Kate Rothko Prizel. © 1998 Kate Rothko Prizel and Christopher Rothko / Artists Rights Society (ARS), New York.

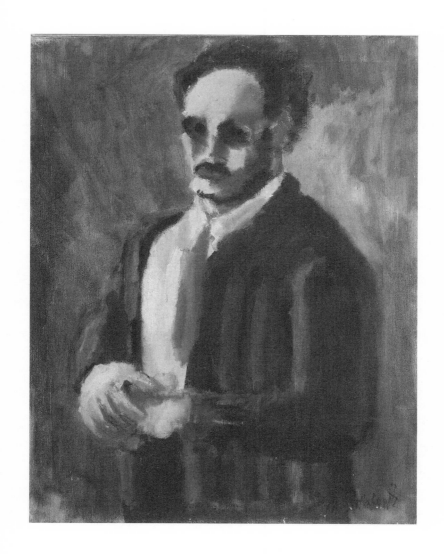

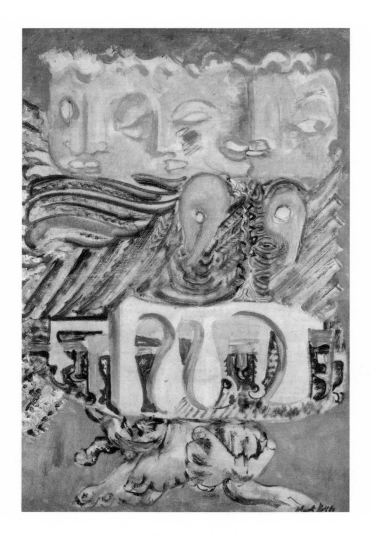

FIGURE 84. Mark Rothko, *The Omen of the Eagle*, 1942. Oil and graphite on canvas, 25 3/4 x 17 3/4 inches. National Gallery of Art, Washington, D.C.; Gift of The Mark Rothko Foundation, Inc. (1986.43.107). © 1998 Kate Rothko Prizel and Christopher Rothko / Artists Rights Society (ARS), New York.

FIGURE 85. Barnett Newman, *Euclidean Abyss*, 1946–1947. Oil and gouache on canvas board, 27 3/4 x 21 3/4 inches. Photo courtesy Mary Zlot and Associates, San Francisco. © 2003 Barnett Newman Foundation / Artists Rights Society (ARS), New York.

His principal problem is to discover what his true subject is. And since painting is his thought's medium, the resolution must grow out of the process of painting itself.

Robert Motherwell*

FOUR *Subjects of the Artist*

"To us art is an adventure into an unknown world, which can be explored only by those willing to take the risks." As much as declaring a principle, that first article of aesthetic belief enunciated by Gottlieb and Rothko described a situation. The metaphor of the voyage into the unknown was a favorite one among these artists. Robert Mother-well invoked it in the titles he gave to his paintings. Commenting later on *The Voyage* (1949) (fig. 87), he observed, "The title refers to the sense we had in the 1940s of voyaging on unknown seas . . . and, of course, refers to Baudelaire's famous poem *The Voyage*, the last line of which is: 'Au fond de l'Inconnu pour trouver du *nouveau!*'"[1]

The Gottlieb-Rothko letter reflects not only the particular quality of their imagery and their concerns but, as well, the seriousness of

purpose that moved this generation. Having abandoned the realisms of the thirties as well as orthodox academic abstraction, seeking sanction for their reinvention of painting, they turned to the ancient origins of image-making. Guided in part by the intellectual lead of Surrealism, these artists sought universality of experience in the realms of the primitive and the mythic; they sought to find painting anew in the symbolic and the archetypal, which offered the support of ancient traditions reaching well beyond the academies and conventions of European culture. If their imagery retained a mimetic element, the representational reference was to transcendent realms of the imagination.

They struggled with formal problems, like the integrity of the picture plane, in ethical terms: "We wish to reassert the picture plane. We are for flat forms because they destroy illusion and reveal truth." Despite the real sense of communal excitement, the sense of reinventing the art of painting, "starting from scratch" (Newman), each artist's voyage of discovery had of necessity to be an intensely personal venture. Their abstractions, as Clement Greenberg observed of Pollock's in 1943, were "not so abstract."[2] Their compositions involved "abstract" figures in surreal landscapes, masks and beasts, totemic creatures, biomorphic forms, textures redolent of the geological—a genetic iconography. As well as the inspiration of primitive and archaic art, their work attested various debts to European modernism, Cubism and Surrealism, in particular, as well as to the expressionism of the Mexican muralists. And that very acknowledgment also confirmed their participation in world art.

Such image-making bore witness to their status as artist. That experience of a shared "world of the imagination" brought confidence both personal and professional. Once embarked on that voyage, each artist moved toward discovery of himself, of himself as

artist; each developed a personal iconography that was to become more than a hallmark of style.

In 1946–1947 Newman's exploration of painting's possibilities led him to the fault line within the pictorial field, in the painting he called *Euclidean Abyss* (fig. 85 above). "What happened there," he explained in an interview two decades later, was that I'd done this painting and stopped in order to find out what I had done, and I actually lived with that painting for almost a year trying to understand it. I realized that I'd made a statement which was affecting me and that was, I suppose, the beginning of my present life, because from then on I had to give up any relation to nature, as seen." Denying that his pictures are "mathematical or removed from life," he distinguished them from the kind of abstractions that "are really nature paintings"—referring explicitly to Kandinsky and implicitly to Gorky. The conventions of compositional placement, he implied, can turn abstract shapes like triangles or circles into bottles, trees, or buildings. The essential reductiveness of his discovered structure precluded such mimetic allusion without, however, depriving it of its human relation. "I removed myself from nature, but," he insisted, "I did not remove myself from life."[3] The distinction is important.

A more radical disengagement, he felt, came the following year in the painting he titled *Onement I*: a roughly edged orange band—what Newman was to call a "zip"—down the axis of a vertical siena field (fig. 88). "What it made me realize," he later recalled, "is that I was confronted for the first time with the thing that I did, whereas up until that moment I was able to remove myself from the act of painting, or from the painting itself. The painting was something that I was making, whereas somehow for the first time with this painting the painting itself had a life of its own."

Newman's "zip" was an invention in the fullest sense: a discovery, of an icon for and of himself. However it may appear, in art historical retrospect, a logical development out of his previous art, the fact that *Onement I* confronted the artist, forced its recognition upon him, is significant. As Newman recalls it, the experience was rather like the specular confrontation with a self-portrait, facing oneself as an other. Intentionality here seems less volitional than responsive. If the image seems to have been invested with a certain inevitability, this was hardly clear to its inventor. Once discovered, however, it became the image of the artist; from then on, Newman was to identify, and be identified, with his "zip." The motif—better, the gesture—became an expressive means, at once language and vocabulary. And in titling his painting Newman acknowledged its originary status.

Also in 1948, Motherwell discovered an essential identity, more multiform, in and through the pictorial structure that would come to be known as "Elegy to the Spanish Republic." First established in a small image, an ink drawing with lines from a poem by Harold Rosenberg (fig. 89), the motif fuses formal meaning into a highly charged iconic format; laden with expressive potential, it posits a pictorial thesis that will continue to confront and challenge the artist. The icon itself is relatively simple in structure but fraught with tension: broadly brushed vertical bars compressing between them organically shaped irregular ovals, all in black.

Once stated, however, the particular dynamics of this structure recall still earlier declarations in Motherwell's work, such as *The Little Spanish Prison* of 1941 (fig. 90). There, in a canvas from his first year as a full-time painter, Motherwell realized something like a heroic struggle in the entrapment of a short horizontal unit within a system of modulated vertical bars. From the beginning, too, he

evoked through titles the moral and political experience that epitomizes the frustrated idealism of the 1930s. Perhaps more clearly than any other, Motherwell's image renews the sense of commitment of those years. But his is more than a merely political response. As Motherwell's evocation of the Spanish Civil War acquired a growing resonance in the series of "Spanish Elegies" over the course of his career, it assumed a more general meaning; expanding beyond the immediate occasion, it acquired the status of myth: subject matter valid because it is indeed tragic and timeless (fig. 91). "The 'Spanish Elegies' are not 'political,' but my private insistence that a terrible death happened that should not be forgot. They are as eloquent as I could make them. But the pictures are general metaphors of the contrast between life and death, and their interrelation."[4]

The shapes themselves, broadly conceived and deliberately laid down, carry their own *gravitas*, a weight that is at once physical and ethical, a pace and ponderousness that establish mood. And in the physiognomy of those shapes we come to recognize the rhythms of the artist. Through his gesture the artist declares the presence of his persona: "It has to do with one's own inner sense of weights: I happen to be a heavy, clumsy, awkward man, and if something gets too airy, even though I might admire it very much, it doesn't feel like my *self*, my *I*."[5] In a sense confirmed by the very fact of the continuing series, Motherwell most surely recognized his *self* in the structure of the "Elegies."

In the years immediately following the war, other painters too discovered their pictorial selves. Rothko's painting finally achieved that "large shape" that carried "the impact of the unequivocal" (fig. 92). And as that shape located itself within the field, securely, gravely, and yet with a buoyant fluidity, it reasserted the picture plane in a way

that seemed to realize the program set forth in item four of the Gottlieb-Rothko statement. In retrospect, we recognize the essential personality already seeking expression in the broad and softly brushed blocks of color of the early works. But that personality comes into clear focus in the late 1940s. In the personal iconography of large shapes expanding over large canvases Rothko found himself as a painter and more.

Each of these artists achieved a breakthrough, came into his own (a telling phrase), by an act of recognition, discovering in his work his own proper subject, his own iconography. The search for the elemental quality in primitive art, in archaic myth, in the vastness of geologic time had been a search for roots, as surely as was the Surrealist-inspired automatism that led the artist back into himself. Pollock, in particular, responded with enthusiasm to the Surrealist "concept of the source of art being the unconscious."[6] Giving that concept monumental realization in his own challenge to easel painting—his breakthrough—he managed at the same time to bring it back to native tradition:

> My painting does not come from the easel. I hardly ever stretch my canvas before painting. I prefer to tack the unstretched canvas to the hard wall or the floor. I need the resistance of a hard surface. On the floor I am more at ease. I feel nearer, more a part of the painting, since this way I can walk around it, work from the four sides and literally be *in* the painting. This is akin to the method of the Indian sand painters of the West.

From kinship with the primitive, he moved to the psychic displacement of the automatic:

When I am *in* my painting, I'm not aware of what I'm doing. It is only after a sort of "get acquainted" period that I see what I have been about. I have no fears about making changes, destroying the image, etc., because the painting has a life of its own. I try to let it come through. It is only when I lose contact with the painting that the result is a mess. Otherwise there is pure harmony, an easy give and take, and the painting comes out well.[7]

Pollock's one-man show at the Betty Parsons Gallery in early 1949 included twenty-six works from the previous year, numbered 1 to 26, some with further descriptive titles. *Number One* was qualified as "aluminum, black, white, oil on canvas, horizontal" (fig. 93; color plate IV). That rather straightforward description, along with the dimensions (68 x 104 inches), gave the essential facts of the picture. It is also as provocative as the picture itself, a painting ostensibly without a subject, an image made of skeins of paint, dripped, squeezed, pressed, smeared, and stained, interweaving and coagulating on a surface of raw canvas. Out of that complexity of line and color, however, the image emerges, sitting comfortably within the field, bounded and, to a degree, determined by its dimensions and proportions. It is a large canvas, but definitely on a human scale, comfortably proportioned; responding to the phenomenological invitation of that scale, the viewer gauges it against the module of his or her own being. And that invitation is made all the more urgent by the single "representational" elements in the composition: the hand prints in the upper corners of the canvas. These most human marks—like those of the Paleolithic cave painters, of which Pollock was aware—the direct imprints of his own hands, declare the painter's immediate presence in the work; like the fingerprints they are, they attest to his uniqueness.

Their reach, toward the upper and outer limits of the field, just beyond the span of our own outstretch, imbues format with affect. These signs of human marking and making articulate the energies of the image, confirming mimetic significance and aspiration. Below, with more conventional legibility, the signature, almost redundantly, declares the presence of the artist, while the date grounds the whole complex in temporal reality.

A heightened awareness of the sheer physicality of painting, as act and art, is shared by this generation of artists. For each, the confrontation with the canvas assumed a particular force, as the initial gesture of marking opened a dialogue of creative challenge, an engagement with the emerging image that was fraught with doubt as well as promise—as though confirming the Gottlieb-Rothko definition of art as "an adventure into an unknown world, which can be explored only by those willing to take risks."

The very choice of the size and shape of the canvas was charged, for the painter was selecting the arena in which he was to operate; the field that challenged his whole being to create an image had, of necessity, to be large. By 1950 several of these painters were opting for canvases some eighteen feet in length. Only such a field could adequately accommodate the full rhythmic sweep of Pollock's pictorial choreographics, the gestures by which he defined his painting and his image (fig. 94).

Newman too found his fullest realization in an extended format, and he wanted the viewer to share his experience of such a field. If the iconic vertical format of the paintings he entitled *Onement* initiated a dialogic relation with the viewer, the monumental horizontal expanse of subsequent canvases, such as *Vir Heroicus Sublimis* of 1950–1951 (fig. 95), engaged the viewer in a more active, indeed

narrative, mode; here, visual scansion leads the body into motion. Despite their size, however, Newman insisted that his large pictures be viewed from close up, as he declared in a statement tacked on the wall at his second exhibition at the Betty Parsons Gallery in 1951: "There is a tendency to look at large pictures from a distance. The large pictures in this exhibition are intended to be seen from a short distance."[8] He was clear where and how he wanted to meet the viewer: "the painting should give a man a sense of place," he declared, so

> that he knows that he's there, so he's aware of himself. In that sense he relates to me when I made the painting because in that sense I was there. . . . I hope that my painting has the impact of giving someone, as it did me, the feeling of his own totality, of his own separateness, of his own individuality, and at the same time of his connection to others, who are also separate. . . . I think you can only feel others if you have some sense of your own being.[9]

The existential resonance of this declaration of principle is clear. Newman's invitation to the viewer to achieve "a sense of [his/her] own scale" reflects a strong need to connect, to communicate; it is a need he shared with his generation of New York painters, to "make the spectator see the world our way—not his way" (Gottlieb-Rothko). Suspicious of distanced critical commentary, these painters urged instead a direct engagement of their pictures, to reflect the directness with which they were created.

De Kooning avoided such lateral extension of the field; he claimed to be uncomfortable with the big canvas. "My paintings are too complicated," he explained (fig. 96). "I'd be working on them

forever after. I don't use large-size canvas because it's too difficult for me to get out of it."[10] The field of the canvas was a space of engagement, and disengagement; the decision when to stop was an issue. The problem of when a painting was finished was an ancient one. Claiming that he tried to avoid the question, de Kooning declared rather, "I paint myself out of the picture, and when I have done that, I either throw it away or keep it. I am always in the picture somewhere. The amount of space I use I am always in, I seem to move around in it, and [then] there seems to be a time when I lose sight of what I wanted to do, and then I am out of it."[11] Unimpressed (in 1951) by the "space of science" and the "physicists' stars" and musing on the spatial needs of the artist, de Kooning declared: "If I stretch my arms next to the rest of myself and wonder where my fingers are—that is all the space I need as a painter."[12]

The reach of the artist's own body, in some Vitruvian sense, controls the scale of things, establishes the essential anthropometric of his imagery, the structural arena of his own body's actions. When that norm is stretched just beyond reach, as in Pollock's *Number 1A, 1948*, we feel it (fig. 93; color plate IV). The handprints of the painter in the upper corners of this canvas, traces of the artist, articulate the strain most eloquently by reminding us of the corporal standard by which we gauge our response. Measuring ourselves against the pictorial field, we discover that "sense of place" that is, as Newman said, a gift of painting, and through which we share in the experience of the painter, who "was there" before we were. Communication no longer depends upon the evocation of the primitive and the archaic, on the iconographic suggestiveness of titles. With and through the emerging image, the artist discovered his sense of self; he discovered his sense of his own being in the act of painting. Existentialism "was

in the air," as de Kooning recalled. "Without knowing too much about it, we were in touch with the mood. I read the books, but if I hadn't I would probably be the same kind of painter. I live in my world."[13]

By the end of the 1940s this generation of artists had indeed found its own subjects. Whatever their debt to the experience of the primitive and the mythic or to the example of Surrealism and the exploration of the unconscious, each had discovered his own distinctive style; each had created a uniquely individual art. Motherwell's "Elegies," Newman's "zips," Rothko's fields of color, Pollock's choreographic skeins—each represented a coming to maturity, a discovery of a proper subject. In each of these pictorial declarations we recognize an iconography of the self—what we rather casually, but significantly, call their "signature style."

Two traditional issues emerge with renewed urgency as crucial to the situation of the American painter in the forties. Articulated by Emerson a century before, they are questions of identity: What is painting? What is an artist? In search of answers to both, this generation used one question to respond to the other. In a kind of persistent and assertive tautology, they demonstrated that the answer lay in the very act of painting: in making a painting the painter defines himself. Harold Rosenberg was the first critic to appreciate this dimension of these painters' achievement in an important, but now much-maligned, essay of 1952, "The American Action Painters."[14] In it he perceived the historical challenge confronting this generation and their response: "Many of the painters were 'Marxists' (WPA unions, artists' congresses); they had been trying to paint Society. Others had been trying to paint Art (Cubism, Post-Impressionism)—it amounts to the same thing." "The big moment came," he continued, "when it

was decided to paint . . . just TO PAINT. The gesture on the canvas was a gesture of liberation, from Value—political, esthetic, moral." And yet, a gesture so fraught could hardly be without value. Too much is at stake.

Painting involves a self-conscious and therefore self-defining decision: to paint is an affirmation of self, of the self as artist. "Painting is self-discovery," as Pollock confessed. "Every good artist paints what he is."[15] This was a truth recognized long ago—formulated in the Renaissance maxim *ogni dipintore dipinge se*: every painter paints himself. Its (re)discovery allowed the confidence—and the corollary anxiety—that informed the art of this generation of painters in America. In finding their proper subjects, these painters discovered both themselves and their art. And in that double discovery—having truly achieved its independence and having overcome the formal obstacles of a puritan aesthetic—painting, finally, had secured its position in America.

That raises the question of the image's truth.
The image must be of the nature of its creator.
It is the nature of its creator increased,
Heightened. . . .
—Wallace Stevens[16]

FIGURE 87. Robert Motherwell, *The Voyage*, 1949. Oil and tempera on paper, mounted on composition board, 48 x 94 inches. The Museum of Modern Art, New York; Gift of Mrs. John D. Rockefeller III. © Dedalus Foundation, Inc. / Licensed by VAGA, New York, New York.

FIGURE 89. Robert Motherwell, *Elegy to the Spanish Republic No. 1*, 1948. India ink on paper, 10 3/4 x 8 1/2 inches. The Museum of Modern Art, New York; Gift of the artist (639.1987). © Dedalus Foundation, Inc. / Licensed by VAGA, New York, New York. Digital image © The Museum of Modern Art / Licensed by SCALA / Art Resource, New York.

FIGURE 88. (*Opposite*). Barnett Newman, *Onement I*, 1948. Oil on canvas and oil on masking tape on canvas, 27 1/4 x 16 1/4 inches. The Museum of Modern Art, New York; Gift of Annalee Newman (390.1992). © 2003 Barnett Newman Foundation / Artists Rights Society (ARS), New York. Digital image © The Museum of Modern Art / Licensed by SCALA / Art Resource, New York.

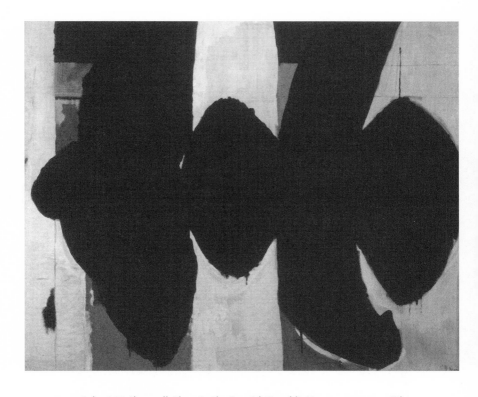

FIGURE 91. Robert Motherwell, *Elegy to the Spanish Republic No. 34*, 1953–1954. Oil on canvas, 80 x 100 inches. Collection Albright-Knox Art Gallery, Buffalo, New York; Gift of Seymour H. Knox, 1961. © Dedalus Foundation, Inc. / Licensed by VAGA, New York, New York.

FIGURE 90. (*Opposite*). Robert Motherwell, *The Little Spanish Prison*, 1941. Oil on canvas, 27 1/8 x 17 1/8 inches. The Museum of Modern Art, New York; Gift of Renate Ponsold Motherwell (343.1983). © Dedalus Foundation, Inc. / Licensed by VAGA, New York, New York.

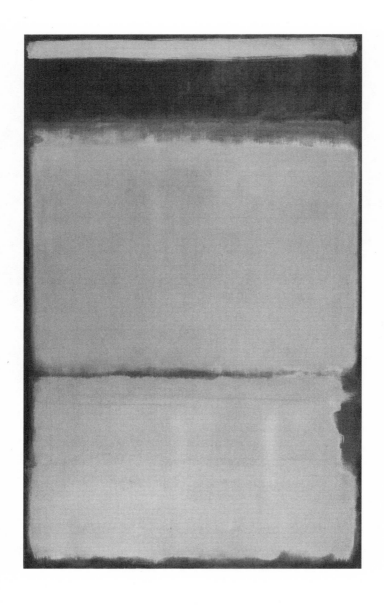

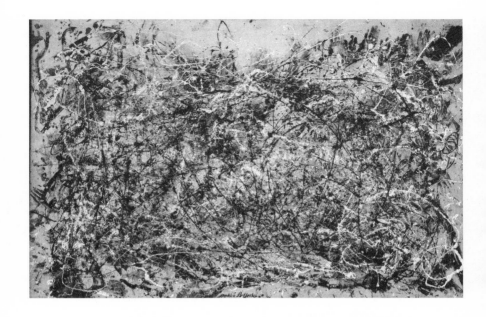

FIGURE 93. Jackson Pollock, *Number 1A, 1948*, 1948. Oil and enamel on canvas, 68 x 104 inches. The Museum of Modern Art, New York; Purchase (77.1950). © 2003 The Pollock-Krasner Foundation / Artists Rights Society (ARS), New York. Digital image © The Museum of Modern Art / Licensed by SCALA / Art Resource, New York.

FIGURE 92. (*Opposite*). Mark Rothko, *Number 10, 1950*, 1950. Oil on canvas, 90 3/8 x 57 1/8 inches. The Museum of Modern Art, New York; Gift of Philip Johnson (38.1952). © 1998 Kate Prizel Rothko and Christopher Rothko / Artists Rights Society (ARS), New York. Digital image © The Museum of Modern Art / Licensed by SCALA / Art Resource, New York.

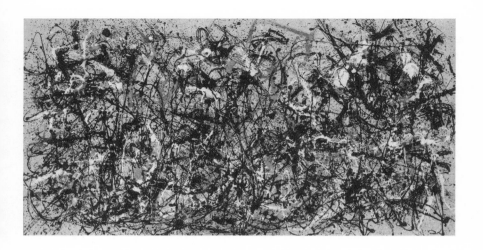

FIGURE 94. Jackson Pollock, *Autumn Rhythm: Number 30, 1950*, 1950. Oil and enamel on canvas, 105 x 207 inches. The Metropolitan Museum of Art, New York; George A. Hearn Fund, 1957 (57.92). © 2003 The Pollock-Krasner Foundation / Artists Rights Society (ARS), New York.

FIGURE 95. Barnett Newman, *Vir Heroicus Sublimis*, 1950–1951. Oil on canvas, 95 3/8 x 213 1/4 inches. The Museum of Modern Art, New York; Gift of Mr. and Mrs. Ben Heller (240.1969). © 2003 Barnett Newman Foundation / Artists Rights Society (ARS), New York. Digital image © The Museum of Modern Art / Licensed by SCALA / Art Resource, New York.

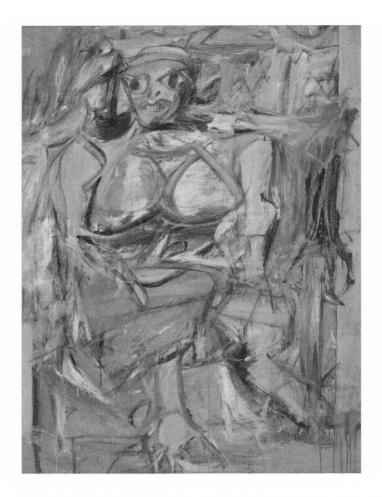

FIGURE 96. Willem de Kooning, *Woman I*, 1950–1952. Oil on canvas, 75 7/8 x 58 inches. The Museum of Modern Art, New York; Purchase. © 2003 The Willem de Kooning Foundation / Artists Rights Society (ARS), New York. Digital image © The Museum of Modern Art / Licensed by SCALA / Art Resource, New York.

AFTERWORD*

Viewing the years around 1950 as a moment of arrival in the history of painting in America, I realize, may open me to charges of aesthetic bias and partisan pleading. I admit to the bias and have already confessed that my vision of that history has necessarily been colored in part by the experience of Abstract Expressionism.[1] But only in part, for in coming to critical terms with the art of Copley one must acknowledge the particular difficulties and challenges faced by the colonial painter in his studio. Out of such circumstances, confronting obdurate objects, human and manufactured, he forged an art of intense and compelling visuality. It was, in fact, consideration of Copley's imagery that led to the earliest formulation of my thesis; the dilemma

confronting the colonial master seemed to set a model for understanding the achievements of subsequent painters in America.[2]

What interests me above all, and what seemed to me to run as a continuous theme through the history of painting in this country, is precisely those studio problems shared by artists. However much the sociocultural circumstances surrounding the production and consumption of art may have changed over the course of our history, the painter and his art faced a continuing ambivalence of purpose and insecurity of position.[3] That situation defined the challenge to and the promise of painting in America. So it may be fair to say that it was dealing with the situation of Copley in eighteenth-century Boston that helped to shape my understanding of the situation of painters in mid-twentieth-century New York.

The kind of critical history of art I am seeking is what I have called a studio history, one that focuses on the artist, the work, and the artist in the work. Of course, such focus can hardly ignore the larger resonance surrounding artistic creation—the historical, social, economic, and biographical conditions of production. Much of recent scholarship on American painting has been devoted to such contextualism. An early generation of art historians, those who first shaped the field, had gathered much of relevance, searching among the papers of the past, setting the art into the sweep of American history, but theirs had been an essentially antiquarian approach as they chronicled the progress of art in this country.[4] Their successors, intellectually more ambitious, expanded the range of vision and offered more sophisticated and nuanced critical approaches to both the art and its contexts. Exploring the social status and religious affiliations of Copley's sitters, for example, permitted a fuller understanding of the function and larger significance of his portraits.[5] Fur-

ther on, the dimensions of meaning in landscape painting were seen to acquire new complexity. Beyond the evident patriotism of the pictorial celebration of the new land scholars discerned patterns of thought and imagination that link such imagery to contemporary philosophy and science in America, to political and economic forces shaping the developing country, to social systems and concerns.[6]

American self-image, as manifest in its art, proved to be fraught with paradox and contradiction, marked by displacements and sublimations, especially as the scope of inquiry extended beyond the traditionally respected categories of portrait and landscape, and the always problematic history painting, to include not only genre painting but also the less ambitious arts of popular prints and other manifestations of visual and material culture, as well as issues of class, race, and gender.[7] Back in the studio, the psychology of the artist himself has emerged as a field of ambitious hermeneutic endeavor.[8]

Twenty years ago the study of American art still assumed a disciplinary attitude that was essentially apologetic. Its effort to modernize, to make itself more intellectually respectable, was defined by one of the leaders of the field as a change "from the traditional study of the *history of art* to the study of *art history*."[9] In the *history of art*, he explained, "the subject is *art*, and the study is of the patterns of causation—stylistic, iconographic, technical—that have shaped its development." The task of previous scholarship had been fundamentally taxonomic, the classification of "objects we call art" according to criteria of "authorship, chronology, national and individual styles, and authenticity." Now, however, "art is being increasingly perceived as a means as well as an end, and in *art history* the subject is *history*, especially social and cultural history." The goal of scholarship becomes the achievement of "a more

profound understanding of individuals and societies, and works of art provide tangible evidence."

Jules Prown's words have proved to be prescient, and works of art have indeed all too often become "tangible evidence" for something else, something of presumably greater import than the painted image. In my more modest sense of a studio history of art, I prefer to take the work of art as tangible evidence of itself, of its making and of its maker. I believe that—although it may indeed document some aspect of historical moment, of social life, of political, economic, or religious ideology—the primary obligation of a painting, as a work of art, is to testify to its own creation. In this, it should be clear, I am unwilling to abandon the critical challenges of the *history of art.* The subject is *art.*

In viewing Abstract Expressionism as a moment of arrival in the history of painting in America, I do of course embed that art in history. The achievement of those artists in New York must be viewed, historically, against the background of modernism in America, the continuing debate over art in America and American art.[10] Effectively overcoming the limitations of that debate, their achievement was, as I have described, a form of self-recognition. Their major discovery was of themselves as artists. And that discovery could only come reflectively, as it were, a truth found in the paintings they were making. To the *what* and the *how* of painting was added the *who*: the subject of art was the artist. This resolution of a fundamental studio tension established an entirely new basis for the making of art in America.

What followed—whether the subsequent explorations of the pioneers themselves or the responsive resistance of younger generations—no longer had to confront the great question of what it meant to declare oneself an artist in America. Whatever the contin-

uing stress in the studio, the continuing challenge of the blank canvas, the success of Abstract Expressionism following circa 1950 did occur in changing circumstances—the increasingly supportive structures of the commercial galleries and museums, and, on an international scale, the appropriation of the art for cultural propaganda. That success, hard won in the studio, has become the object of much revisionist historiography, which has undeniably added a thicker contextual resonance to our understanding of Abstract Expressionism.[11] *Art history* perhaps, but I am not convinced that it has added significantly to our understanding of the *art* itself. Critical discourse, if it is indeed to be truly critical, must return to a confrontation of the canvases, to acknowledge the true subject of the artist.

In the opening decades of the second half of the twentieth century, Pop, Minimalist, Conceptualist, Earth Artists, Feminists, and others have challenged the aesthetics of Abstract Expressionism and, indeed, the art of painting itself, and through their various challenges they have transformed our notions of art. But these younger generations have also enjoyed a freedom to play serious aesthetic games precisely because their predecessors had resolved the basic issue, securing the position of painting in America. Those following Abstract Expressionism, in effect, no longer had to confront the tensions of an American tradition in which the situation of art and the artist was precarious, in which the very conditions of artistic production proved a constant challenge to creativity. In this respect Abstract Expressionism represents the culmination of that tradition, a moment of tensions finally resolved and the realization of painting's promise in America. America itself was no longer in the aesthetic shadow of Europe. Painting had established its place in this country, and art had gained its freedom to be.

NOTES

Stuart Davis quoted in Brian O'Doherty, *American Masters: The Voice and the Myth in Modern Art* (New York: Dutton, 1973), 53; Willem de Kooning in "Content Is a Glimpse . . . ," excerpts from an interview (1960) with David Sylvester (BBC), reprinted from *Location* 1 (spring 1963) in Thomas B. Hess, *Willem de Kooning* (New York: Museum of Modern Art, 1968), 47; also in David Sylvester, *Interviews with American Artists* (New Haven: Yale University Press, 2001), 48.

Foreword

* Ralph Waldo Emerson, "Thoughts on Art," *The Dial* 1:3 (January 1841): 367–378; reprinted in John W. McCoubrey, *American Art, 1700–1960: Sources and Documents* (Englewood Cliffs, N.J.: Prentice-Hall, 1965), 70–80.

1. Irving Sandler, *The Triumph of American Painting: A History of Abstract Expressionism* (New York: Harper and Row, 1970). Sandler's book was actually preceded by William C. Seitz's Ph.D. dissertation (Princeton University, 1955), which was published later as *Abstract Expressionist Painting in America* (Cambridge, Mass.: Harvard University Press for the National Gallery of Art, 1983).

2. Henry R. Luce, "The American Century," *Life* (February 17, 1941): 61–65.

3. See, most notably, Serge Guilbaut, *How New York Stole the Idea of Modern Art: Abstract Expressionism, Freedom, and the Cold War* (Chicago: University of Chicago Press, 1983); see as well the essays collected in Francis Frascina, ed., *Pollock and After: The Critical Debate* (London: Harper and Row, 1985).

4. The leading critical voice here is that of Clement Greenberg: see, e.g., "'American-Type' Painting," *Partisan Review* 22:2 (1955): 179–196; reprinted in his *Art and Culture: Critical Essays* (Boston: Beacon, 1961), 208–229.

5. In this regard my own position, as will become clear, would be closer to that of Harold Rosenberg: see especially his essay "The American Action Painters," *Art News* 51:8 (December 1952): 22–23, 48–50; reprinted in *The Tradition of the New* (New York: Horizon, 1959), 23–39, along with "Parable of American Painting," 13–22 therein.

6. Sacvan Bercovitch, *The Puritan Origins of the American Self* (New Haven: Yale University Press, 1975), ix.

7. Asher B. Durand, "Studying from Nature," *The Crayon* 1 (June 6, 1855): 353.

8. The formulation is Meyer Schapiro's, from "Recent Abstract Painting," in his *Modern Art, Nineteenth and Twentieth Centuries: Selected Papers* (New York: Braziller, 1978), 222. The essay was originally published as "The Liberating Quality of Avant-Garde Art," *Art News* 56 (summer 1957): 36–42.

1. Declarations of Independence

* John Swanick, "Poem on the Prospect of Seeing the Fine Arts Flourish in America," *American Museum* 2 (December 1787): 598; quoted from Neil Harris, *The Artist in American Society: The Formative Years, 1790–1860* (New York: Braziller, 1966), 21.

1. Quoted in Brian O'Doherty, *American Masters: The Voice and the Myth in Modern Art* (New York: Dutton, 1973), 53.

2. For the advertisement in the *Boston News-Letter*, see Henry Wilder Foote, *John Smibert, Painter* (Cambridge, Mass.: Harvard University Press, 1950), 77.

3. Copley to [Captain R.G. Bruce?], [1767?]: *Letters and Papers of John Singleton Copley and Henry Pelham, 1739–1776* (Boston: Massachusetts Historical Society, Collections, vol. 71, 1914), 64; in John McCoubrey, *American Art, 1700–1960: Sources and Documents* (Englewood Cliffs, N.J.: Prentice-Hall, 1965), 17.

 On a parochial note: In 1768 Copley painted the portrait of Myles Cooper, second president of Kings College, who persuaded the artist to sell him another picture he had seen in the studio, a nun reading by candlelight. Copley agreed to part with the picture, a model of European chiaroscuro, because he approved of Cooper's intention: to "deposit it in our College Library, as a Beginning to a public Collection." Kings College would have boasted the first public art gallery in the colonies. *Letters and Papers,* 70–72. For the painting itself, see Carrie Rebora, Paul Staiti et al., *John Singleton Copley in America* (New York: Metropolitan Museum of Art, 1995), cat. no. 47.

4. *Letters and Papers,* 65–66; in McCoubrey, *American Art,* 18.

5. Quoted from Lillian B. Miller, *Patrons and Patriotism: The Encouragement of the Fine Arts in the United States, 1790–1860* (Chicago: University of Chicago Press, 1966), 12.

6. West's appeal to the "law of the historian" is recorded in John Galt, *The*

Life, Studies, and Works of Benjamin West, Esq., President of the Royal Academy of London (London: T. Cadell and W. Davies, 1820), 48. On West's *Death of General Wolfe* and its resonance, see Alan McNairn, *Behold the Hero: General Wolfe and the Arts in the Eighteenth Century* (Montreal: McGill-Queen's University Press, 1997).

7. Trumbull's letter to Jefferson from London is printed in *The Autobiography of Colonel John Trumbull* (1841), ed. Theodore Sizer (New Haven: Yale University Press, 1953), 158–162; excerpt in McCoubrey, *American Art*, 40–43.

8. Trumbull, *Autobiography*, 172.

9. Harris, *The Artist in American Society*, 91; see as well 90–122 ("Professional Communities: Growing Pains").

10. Horace Walpole, *Anecdotes of Painting in England* (1762), cited in William Dunlap, *A History of the Rise and Progress of the Arts of Design in the United States* (1834), ed. Frank W. Bayley and Charles E. Goodspeed (Boston: C. E. Goodspeed and Co., 1918), I, 25.

11. Thomas Cole, "Essay on American Scenery," *American Monthly Magazine*, n.s. 1 (January 1836): 1–12; in McCoubrey, *American Art*, 98–110.

12. In McCoubrey, *American Art*, 95–96.

13. "A Description of the Picture and Mezzotinto of Mr. Pitt, done by Charles Willson Peale, of Maryland," the broadsheet accompanying the print of Peale's portrait (1768), is reprinted in Charles Coleman Sellers, *The Artist of the Revolution: The Early Life of Charles Willson Peale* (Hebron, Conn.: Feather and Good, 1939), 89. Peale's portrait of William Pitt (1768) includes "the Statue of British *Liberty*, trampling under Foot the Petition of the Congress at New York." On the search for national symbols, see the fascinating account of Richard S. Patterson and Richardson Dougall, *The Eagle and the Shield: A History of the Great Seal of the United States* (Washington, D.C.: American Revolution Bicentennial Administration, 1976).

14. William Cullen Bryant, *Funeral Oration on the Death of Thomas Cole*

Before the National Academy of Design, May 4, 1848; in McCoubrey, *American Art*, 96. On the pictorial celebration of the artist by Durand, see Ella M. Foshay and Barbara Novak, *Intimate Friends: Thomas Cole, Asher B. Durand, William Cullen Bryant* (New York: New York Historical Society, 2000).

15. Alexis de Tocqueville, *Democracy in America*, trans. Francis Bowen (1840), ed. Phillips Bradley (New York: Knopf, 1945), II, 73 (in chapter 17: "Of Some Sources of Poetry Among Democratic Nations").

16. John Constable, introduction to *Various Subjects of Landscape: Characteristics of English Scenery* (1830–1832); cited in Ronald Paulson, *Literary Landscape: Turner and Constable* (New Haven: Yale University Press, 1982), 140.

17. Worthington Whittredge, "The Autobiography of Worthington Whittredge, 1820–1910," ed. John I. Bauer, *Brooklyn Museum Journal* 1 (1942): 56; in McCoubrey, *American Art*, 121.

18. Margaret Fuller Ossoli, "A Record of the Impressions Produced by the Exhibition of Mr. Allston's Pictures in the Summer of 1839"; in McCoubrey, *American Art*, 58.

19. Horatio Greenough, "Remarks on American Art," in *Travels, Observations, and Experiences of a Yankee Stonecutter* (New York: G. P. Putnam, 1852), 116–126; in McCoubrey, *American Art*, 127.

20. Asher B. Durand, "Letters on Landscape Painting," *The Crayon* 1 (January 17, 1855): 34–35 (letter II); in McCoubrey, *American Art*, 110–112.

21. Robert Henri, "Progress in Our National Art Must Spring from the Development of Individuality of Ideas and Freedom of Expression: A Suggestion for a New Art School," *The Craftsman* 15:. 4 (January 1909): 387–401; excerpt in Patricia Hills, *Modern Art in the USA: Issues and Controversies of the Twentieth Century* (Upper Saddle River, N.J.: Prentice-Hall, 2001), 7–8.

22. Theodore Roosevelt, "A Layman's Views of an Art Exhibition," *The Outlook* (March 22, 1913): 718–720; in McCoubrey, *American Art*,

191–192. Further critical response is collected in *1913 Armory Show, Fiftieth Anniversary Exhibition, 1963*, exhibition catalogue (Utica: Munson-Williams-Proctor Institute, 1963); see as well Milton W. Brown, *The Story of the Armory Show* (1963), 2nd ed. (New York: Abbeville, 1988), ch. 13: "The Effect of the Great Adventure."

23. Kenyon Cox, "The Modern Spirit in Art: Some Reflections Inspired by the Recent International Exhibition," *Harper's Weekly* (March 15, 1913): 10; in McCoubrey, *American Art*, 193–196.

24. Stuart Davis, autobiographical statement in *Stuart Davis* (New York: American Artists Group, 1945), unpaginated; reprinted in Diane Kelder, ed. *Stuart Davis* (New York: Praeger, 1971), 19–30.

25. Thomas Hart Benton, *An Artist in America*, rev. ed. (Kansas City: University of Kansas City Press, 1951), 314; in McCoubrey, *American Art*, 201.

26. Stuart Davis, "The Cube Root," *Art News* 41 (February 1, 1943): 33–34; in McCoubrey, *American Art*, 208.

27. Quoted in James Johnson Sweeney, *Stuart Davis* (New York: Museum of Modern Art, 1945), 23.

2. Style and the Puritan Aesthetic

1. Cited from Oliver W. Larkin, *Art and Life in America* (New York: Rinehart, 1949), 10. Two generations later, following the establishment of the new republic, such practical priorities continued to color thoughts on the fine arts—as in Benjamin Franklin's comparative evaluation of a masterpiece by Raphael, quoted above (p. 4).

2. The poem beneath the skull in Thomas Smith's pious moralizing self-portrait (fig. 25) reads: "Why why should I the World be minding / therin a world of Evils Finding. / Then Farwell World: Farwell thy Jarres / thy Joies thy Toies thy Wiles thy Warrs, / Truth Sounds Retreat: I am not sorye. / The Eternall Drawes to him my heart / By Faith (which

can thy Force Subvert) / To Crowne me (after Grace) with Glory." For fuller consideration of the image and its Puritan context, see Roger Stein, "Thomas Smith's Self-Portrait: Image/Text as Artifact," *Art Journal* 44 (1984): 316–327.

3. Copley to John Greenwood, from Rome, May 7, 1775, in Martha Babcock Amory, *The Domestic and Artistic Life of John Singleton Copley, R.A.* (Boston: Houghton, Mifflin, and Company, 1882), 51.

4. *Letters and Papers of John Singleton Copley and Henry Pelham, 1739–1776* (Boston: Massachusetts Historical Society, Collections, vol. 71, 1914), 44; in John W. McCoubrey, *American Art, 1700–1960: Sources and Documents* (Englewood Cliffs, N.J.: Prentice-Hall, 1965), 12.

5. As reported by Captain R. G. Bruce in a letter to Copley: *Letters and Papers*, 41; in McCoubrey, *American Art*, 10–11.

6. Sir Joshua Reynolds, *Discourses on Art*, ed. Robert W. Wark (New Haven: Yale University Press, 1975), 191, 200 (discourse XI).

7. *Letters and Papers*, 51; in McCoubrey, *American Painting*, 14.

8. William Dunlap, *A History of the Rise and Progress of the Arts of Design in the United States* (1834), ed. Frank W. Bayley and Charles E. Goodspeed (Boston: C. E. Goodspeed and Co., 1918), I, 143.

9. Dunlap, *History of the Rise and Progress*, I, 144.

10. Dunlap, *History of the Rise and Progress*, I, 25.

11. Draft of a letter, cited in Barbara Novak, "Thomas Cole and Robert Gilmor," *Art Quarterly* 25 (spring 1962): 44.

12. On this correspondence, see Novak, "Thomas Cole and Robert Gilmor," 41–53.

13. Cited in James Thomas Flexner, *That Wilder Image: The Painting of America's Native School, from Thomas Cole to Winslow Homer* (Boston: Little Brown, 1962), 65.

14. Asher B. Durand, "Letters on Landscape Painting," *The Crayon* 1 (January 17, 1855): 34–35 (letter II); in McCoubrey, *American Art*, 110–113. On Ruskinian aesthetics in America, see Linda S. Ferber and William

H. Gerdts, *The New Path: Ruskin and the American Pre-Raphaelites* (New York: Schocken, 1985).

15. Asher B. Durand, "Studying from Nature," *The Crayon* 1 (June 6, 1855): 354.

16. Ralph Waldo Emerson, "Thoughts on Art," *The Dial* 1 (January 1841): 367–368; in McCoubrey, *American Art*, 70–80.

17. Asher B. Durand, "Letters on Landscape Painting," *The Crayon* 1 (February 14, 1855): 97–98 (letter IV); in McCoubrey, *American Art*, 113–115.

18. Henry James, *A Landscape Painter* (New York: Scott and Selzer, 1919), 50–51; "A Landscape Painter" was originally published in the *Atlantic Monthly* (1866).

19. Quoted in Flexner, *That Wilder Image*, 47.

20. Thomas Cole, *The Collected Essays and Prose Sketches*, ed. Marshall Tymn (St. Paul, Minn.: Colet Press, 1980), 164.

21. Letter of 1884, in George Inness Jr., *The Life, Art, and Letters of George Inness* (New York: Century Company, 1917), 168–173; in McCoubrey, *American Art*, 121–122.

22. Asher B. Durand, "Letters on Landscape Painting," *The Crayon* (March 7, 1855): 146 (letter V).

23. "On Some Pictures Lately Exhibited," *The Galaxy* 20 (July 1875): 89–97; reprinted in Henry James, *The Painter's Eye: Notes on the Pictorial Arts*, ed. John L. Sweeney (Cambridge, Mass.: Harvard University Press, 1956), 92; also in McCoubrey, *American Art*, 165.

24. For the inscriptions on Eakins's perspective drawing, see Amy B. Werbel, "Perspective in Thomas Eakins' Rowing Pictures," in Helen A. Cooper et al., *Thomas Eakins: The Rowing Pictures* (New Haven: Yale University Press, 1996), 85, 138.

3. Artists of Recognized Standing

* Mark Rothko, "The Romantics Were Prompted," *Possibilities* 1 (winter 1947/48): 84.

1. Stuart Davis, "Why an Artists' Congress?" in *First American Artists' Congress* (New York, 1936), 3; reprinted in Matthew Baigell and Julia Williams, *Artists Against War and Fascism: Papers of the First American Artists' Congress* (New Brunswick, N.J.: Rutgers University Press, 1986), 65.

2. *First American Artists' Congress*, n.p.; in Baigell and Williams, *Artists Against War and Fascism*, 53.

3. *First American Artists' Congress*, n.p.; in Baigell and Williams, *Artists Against War and Fascism*, 47. The "Call" originally appeared in an issue of *New Masses* dedicated to "Revolutionary Art" (October 1, 1935).

4. Max Weber, "The Artist, His Audience, and Outlook," in *First American Artists' Congress*, 42–47; in Baigell and Williams, *Artists Against War and Fascism*, 121–129.

5. Cited in Baigell and Williams, *Artists Against War and Fascism*, 37–38.

6. Reprinted in Baigell and Williams, *Artists Against War and Fascism*, 33–35.

7. Quoted by Davis, "Why an Artists' Congress?" 4–5; in Baigell and Williams, *Artists Against War and Fascism*, 67.

8. Meyer Schapiro, "The Social Bases of Art," in *First American Artists' Congress*, 31–37; in Baigell and Williams, *Artists Against War and Fascism*, 101–113. Also in Meyer Schapiro, *Worldview in Painting—Art and Society: Selected Papers*, ed. Lillian Milgram Schapiro (New York: Braziller, 1999), 119–128.

9. George L. K. Morris, "Art Chronicle," *Partisan Review* 6 (spring 1939): 63; quoted in Baigell and Williams, *Artists Against War and Fascism*, 39.

10. Arshile Gorky, quoted in Irving Sandler, *The Triumph of American Painting: A History of Abstract Expressionism* (New York: Harper and Row, 1970), 10.

11. Barnett Newman, in "Jackson Pollock: An Artist's Symposium," *Art News* 66 (April 1967): 29; reprinted in Barnett Newman, *Selected Writings and Interviews*, ed. John P. O'Neill (New York: Knopf, 1990), 191–192.

12. George L. K. Morris, "The American Abstract Artist: A Chronicle, 1936–56," in American Abstract Artists, *The World of Abstract Art* (London: Tiranti, 1957), 134.

13. Quoted in Julien Levy, *Arshile Gorky* (New York: Abrams, 1966), 15.

14. Much of Gorky's invented biography, including his date of birth, has been revised in the most recent biography of the artist: Hayden Herrera, *Arshile Gorky: His Life and Work* (New York: Farrar, Straus, and Giroux, 2003).

15. On the motif and its meaning for the artist, see Gorky's own statement, in Patricia Hills, *Modern Art in the USA: Issues and Controversies of the Twentieth Century* (Upper Saddle River, N.J.: Prentice-Hall, 2001), 162–163, as well as Harry Rand, *Arshile Gorky: The Implication of Symbols* (Montclair: Allanheld and Schram, and London: Prior, 1980), 71–82.

16. From an interview with Irving Sandler (1959), quoted in Thomas B. Hess, *Willem de Kooning* (New York: Museum of Modern Art, 1968), 17.

17. Quoted in Sally E. Yard, "Willem de Kooning: The First Twenty-Six Years in New York, 1926–1952" (Ph.D. dissertation, Princeton University, 1980), 50.

18. De Kooning, "The Renaissance and Order," *Trans/formation* 1:2 (1951): 85–87; reprinted in Hess, *Willem de Kooning*, 141–143.

19. "The Whitney Dissenters," as quoted in Dore Ashton, *The New York School: A Cultural Reckoning* (New York: Viking, 1973), 78.

20. The challenge was to "the supremacy of the silo," in the words of one member of the group, known as "The Ten." See Ashton, *New York School*, 78.

21. The letter is reprinted in John W. McCoubrey, *American Art, 1700–1960: Sources and Documents* (Englewood Cliffs, N.J.: Prentice-Hall, 1965), 210–212.

22. Adolph Gottlieb and Mark Rothko, "The Portrait and the Modern Artist," transcript of a broadcast on "Art in New York," Radio WNYC,

October 13, 1943; reprinted in *Mark Rothko, 1903–1970*, exhibition catalogue (London: Tate Gallery, 1983), 78–81.

23. "Jackson Pollock," *Arts and Architecture* 61:2 (February 1944): 14; reprinted in Francis V. O'Connor, *Jackson Pollock* (New York: Museum of Modern Art, 1967), 31–33.

24. Reprinted in Newman, *Selected Writings and Interviews*, 107–108.

25. *The Nation* (November 7, 1943); reprinted in Clement Greenberg, *The Collected Essays and Criticism*, ed. John O'Brian, vol. 1 (Chicago: University of Chicago Press, 1986), 165–166.

26. The announcement for the school is illustrated in Frank O'Hara, *Robert Motherwell* (New York: Museum of Modern Art, 1965), 76.

4. Subjects of the Artist

* Robert Motherwell, reviewing Jackson Pollock, "Painters' Objects," *Partisan Review* 11:1 (winter 1944): 93–97; in *The Collected Writings of Robert Motherwell*, ed. Stephanie Terenzio (New York: Oxford University Press, 1992), 27.

1. In H. H. Arnason, *Robert Motherwell*, rev. ed. (New York: Abrams, 1982), 115.

2. Reviewing Pollock's first show at Peggy Guggenheim's Art of This Century gallery in *The Nation* (November 27, 1943): reprinted in Clement Greenberg, *The Collected Essays and Criticism*, ed. John O'Brian, vol. 1 (Chicago: University of Chicago Press, 1986), 165.

3. Interview with David Sylvester (1965), in Barnett Newman, *Selected Writings and Interviews*, ed. John P. O'Neill (New York: Knopf, 1990), 254–259. Also in David Sylvester, *Interviews with American Artists* (New Haven: Yale University Press, 2001), 35–42.

4. Quoted in Frank O'Hara, *Robert Motherwell, with Selections from the Artist's Writings* (New York: Museum of Modern Art, 1965), 54, from

Margaret Paul, in *Robert Motherwell* (Northampton, Mass.: Smith College Museum of Art, 1963), cat. no. 16.

5. "A Conversation with Students" (April 6, 1979), in *Collected Writings*, 228. I have further explored the implications of this statement in " 'My I': Toward an Iconography of the Self," in David Rosand, ed., *Robert Motherwell on Paper: Drawings, Prints, Collages* (New York: Abrams, 1997), 13–38.

6. In response to a questionnaire in *Arts and Architecture* 61 (February 1944): 14; reprinted in Francis V. O'Connor, *Jackson Pollock*, exhibition catalogue (New York: Museum of Modern Art, 1967), 31–33.

7. Jackson Pollock, "My Painting," *Possibilities* 1 (winter 1947/48), 79; reprinted in O'Connor, *Jackson Pollock*, 40.

8. Statement in Newman, *Selected Writings and Interviews*, 178.

9. Interview with David Sylvester, in Newman, *Selected Writings and Interviews*, 257; Sylvester, *Interviews with American Artists*, 40.

10. In Emile de Antonio and Mitch Tuchman, *Painters Painting: A Candid History of the Modern Art Scene, 1940–1970* (New York: Abbeville, 1984), 70.

11. In Robert Motherwell and Ad Reinhardt, eds., *Modern Artists in America* (New York: Wittenborn, Schultz, 1949/50), 12.

12. In his contribution to the symposium at the Museum of Modern Art (February 5, 1951) "What Abstract Art Means to Me," *Bulletin of the Museum of Modern Art* 18:3 (spring 1951); reprinted in Thomas B. Hess, *Willem de Kooning* (New York: Museum of Modern Art, 1968), 143–146, and in Harold Rosenberg, *Willem de Kooning* (New York: Abrams, n.d.), 143–147.

13. Quoted in Irving Sandler, "Conversations with de Kooning," *Art Journal* 48:3 (fall 1989): 217.

14. Harold Rosenberg, "The American Action Painters," *Art News* 51:8 (December 1952): 22–23, 48–50; reprinted in *The Tradition of the New* (New York: Horizon, 1959), 23–39.

15. In Selden Rodman, *Conversations with Artists* (New York: Devin-Adair, 1957), 82; cited in O'Connor, *Jackson Pollock*, 73.
16. "A Mythology Reflects Its Region," in Wallace Stevens, *The Palm at the End of the Mind: Selected Poems and a Play*, ed. Holly Stevens (New York: Knopf, 1971), 398.

Afterword

* Information in notes to the text of the lectures has generally been confined to the publications of sources quoted. For fuller bibliography, as well as a sense of the varieties and directions of recent scholarship in American art, the reader may consult a number of review articles: Elizabeth Johns, "Scholarship in American Art: Its History and Recent Developments," *American Studies International* 22 (October 1984): 3–40; Wanda Corn, "Coming of Age: Historical Scholarship in American Art," *Art Bulletin* 70 (1988): 188–207; and, most recently, John Davis, "The End of the American Century: Current Scholarship on the Art of the United States," *Art Bulletin* 85 (2003): 544–580.

1. Having acknowledged as predecessor in this vision John W. McCoubrey's *American Tradition in Painting* (New York: Braziller, 1963), I must here acknowledge as well his clarification in the preface to the new edition of his book: "Neither my early thinking nor my writing on the sea changes I found grew from a preoccupation with Abstract Expressionism. They were prompted by the very clear-cut differences between American portraiture and its sources in British mezzotints" ([Philadelphia: University of Pennsylvania Press, 2000], xi). For obvious reasons, the year 1950 was also the focus chosen by April Kingsley in *The Turning Point: The Abstract Expressionists and the Transformation of American Art* (New York: Simon and Schuster, 1992).

2. For a similar phenomenological response to Copley, see Barbara Novak,

"Self, Time, and Object in American Art: Copley, Lane, and Homer," in *American Icons: Transatlantic Perspectives on Eighteenth- and Nineteenth-Century American Art*, ed. Thomas W. Gaehtgens and Heinz Ickstadt (Santa Monica: Getty Center for the History of Art and the Humanities, 1992), 61–91.

3. Two important studies of patronage and the social standing of the artist in early America remain standard references: Neil Harris, *The Artist in American Society: The Formative Years, 1790–1860* (New York: Braziller, 1966; repr. Chicago: University of Chicago Press, 1982), and Lillian B. Miller, *Patrons and Patriotism: The Encouragement of the Fine Arts in the United States, 1790–1860* (Chicago: University of Chicago Press, 1966).

4. See, for example, the volumes of James Thomas Flexner: *First Flowers of Our Wilderness* (Boston: Houghton Mifflin, 1947), *The Light of Distant Skies, 1760–1835* (New York: Harcourt Brace, 1954), *That Wilder Image: The Painting of America's Native School from Thomas Cole to Winslow Homer* (Boston: Little Brown, 1962). Also: Oliver W. Larkin, *Art and Life in America* (New York: Rinehart, 1949; rev. and enl. ed., New York: Holt, Rinehart, and Winston, 1960); Virgil Barker, *American Painting: History and Interpretation* (New York: Macmillan, 1950); and E. P. Richardson, *Painting in America: The Story of 450 Years* (New York: Crowell, 1956).

5. Most important in opening new prospects on Copley and his world was Jules David Prown, *John Singleton Copley*, 2 vols. (Cambridge, Mass.: Harvard University Press, 1966). For the most recent scholarship on the artist, see Carrie Rebora, Paul Staiti et al., *John Singleton Copley in America* (New York: Metropolitan Museum of Art, 1995).

6. For the particular poetry and philosophy of American landscape painting, see especially Barbara Novak, *American Painting of the Nineteenth Century: Realism, Idealism, and the American Experience* (New York: Praeger, 1969; 2nd ed., New York: Harper and Row, 1979), and idem, *Nature and Culture: American Landscape and Painting, 1825–1875* (New

York: Oxford University Press, 1980; 2nd ed., 1995), in which Erwin Panofsky's notion of iconology (as a history of "cultural symptoms or 'symbols'") is taken as a model. A more skeptical view of this art, stressing its ideological ambivalence, is offered by Angela Miller, *The Empire of the Eye: Landscape Representation and American Cultural Politics, 1825–1875* (Ithaca: Cornell University Press, 1993). A younger generation of scholars has continued to enlarge the scope of such study, exploring the complexities of the art of individual painters. See, most recently, Adrienne Baxter Bell, *George Inness and the Visionary Landscape* (New York: National Academy of Design and Braziller, 2003), which expands and deepens our understanding not only of the spiritual and intellectual life of the artist and his milieu but of the very qualities of his pictorial surfaces.

7. See, e.g., Elizabeth Johns, *American Genre Painting: The Politics of Everyday Life* (New Haven: Yale University Press, 1991), and David M. Lubin, *Picturing a Nation: Art and Social Change in Nineteenth-Century America* (New Haven: Yale University Press, 1994), as well as the thematic and methodological range reflected in two useful anthologies: David C. Miller, ed., *American Iconology: New Approaches to Nineteenth-Century Art and Literature* (New Haven: Yale University Press, 1993), and Marianne Doezema and Elizbeth Milroy, eds., *Reading American Art* (New Haven: Yale University Press, 1998). Further references will be found in the review article by Davis, "The End of the American Century." For another dimension of recent scholarship in the field, see Sally M. Promey, "The 'Return' of Religion in the Scholarship of American Art," *Art Bulletin* 85 (2003): 581–603.

8. See especially the critically complex reading of Michael Fried, *Realism, Writing, Disfiguration: On Thomas Eakins and Stephen Crane* (Chicago: University of Chicago Press, 1987). The personae of American artists of the nineteenth century have been subjected to some intense psychoanalytical interpretation: see, e.g., Bryan Jay Wolf, *Romantic Re-Vision:*

Culture and Consciousness in Nineteenth-Century American Painting and Literature (Chicago: University of Chicago Press, 1982), and Alexander Nemerov, *The Body of Raphaelle Peale: Still Life and Selfhood, 1812–1824* (Berkeley: University of California Press, 2001).

9. Jules David Prown, "Editor's Statement: Art History vs. the History of Art," *Art Journal* 44 (1984): 313–314.

10. Here in particular much recent scholarship has been devoted essentially to redescribing and interpreting art that had been marginalized in the story of modernism: see, e.g., Wanda Corn, *The Great American Thing: Modern Art and National Identity, 1915–1935* (Berkeley: University of California Press, 2000), and Erika Lee Doss, *Benton, Pollock, and the Politics of Modernism: From Regionalism to Abstract Expressionism* (Chicago: University of Chicago Press, 1991). The several ideological dimensions of twentieth-century art in America have also been the object of recent study: e.g., by Allan Antliff, *Anarchist Modernism: Art, Politics, and the First American Avant-Garde* (Chicago: University of Chicago Press, 2001), and Andrew Hemingway, *Artists on the Left: American Artists and the Communist Movement, 1926–1956* (New Haven: Yale University Press, 2002).

11. As previously noted, the sociopolitical critique of Abstract Expressionism has been most powerfully made by Serge Guibault, *How New York Stole the Idea of Modern Art: Abstract Expressionism, Freedom, and the Cold War* (Chicago: University of Chicago Press, 1983); it was further explored in Francis Frascina, ed., *Pollock and After: The Critical Debate* (London: Harper and Row, 1985).

Beyond works cited in the notes to the text—and in addition to the monographic studies of individual artists and exhibition catalogues—the steadily growing literature on the subject includes: Stephen C. Foster, *The Critics of Abstract Expressionism* (Ann Arbor: UMI Research Press, 1980); Annette Cox, *Art-as-Politics: The Abstract Expressionist Avant-Garde and Society* (Ann Arbor: UMI Research Press, 1982); Michael Auping, ed.,

Abstract Expressionism: The Critical Developments (New York: Abrams in association with the Albright-Knox Gallery, 1987); Alwynne Mackie, *Art/Talk: Theory and Practice in Abstract Expressionism* (New York: Columbia University Press, 1989); David Anfam, *Abstract Expressionism* (London: Thames and Hudson, 1990); Ann Eden Gibson, *Issues in Abstract Expressionism: The Artist-Run Periodicals* (Ann Arbor: UMI Research Press, 1990); Clifford Ross, ed., *Abstract Expressionism: Creators and Critics—An Anthology* (New York: Abrams, 1990); David Shapiro and Cecile Shapiro, eds., *Abstract Expressionism: A Critical Record* (Cambridge: Cambridge University Press, 1990); Stephen Polcari, *Abstract Expressionism and Modern Experience* (Cambridge: Cambridge University Press, 1991); Michael Leja, *Reframing Abstract Expressionism: Subjectivity and Painting in the 1940s* (New Haven: Yale University Press, 1993); Claude Cernuschi, *"Not an illustration but the equivalent": A Cognitive Approach to Abstract Expressionism* (Madison, N.J.: Fairleigh Dickinson University Press; London: Associated University Presses, 1997); Ann Eden Gibson, *Abstract Expressionism: Other Politics* (New Haven: Yale University Press, 1997); John Golding, *Paths to the Absolute: Mondrian, Malevich, Kandinsky, Pollock, Newman, Rothko, and Still* (Princeton: Princeton University Press, 1997); Nancy Jachec, *The Philosophy and Politics of Abstract Expressionism* (Cambridge: Cambridge University Press, 2000).

INDEX

Luce, Henry, xxi

McCoubrey, John, *American Tradition in Painting*, xii-xiii, 199*n*1
Macdonald-Wright, Stanton, 18
Manet, 67
Marxists, 169
Matisse, 18, 19
Mexican muralists, 160
Michelangelo, 2
Minimalist art, 185
Miró, 120
Monet, 63, 66
Morris, George L. K., 118
Motherwell, Robert, 132, 159, 169; *The Voyage*, 159, 162–163, fig. 87; "Elegy to the Spanish Republic," 162, fig. 89; *The Little Spanish Prison*, 162–163, fig. 90
Munich, 17
Museum of Modern Art, xxii

National College, 7
Negro jazz music, 19
New England, 52
New World, 2, 7, 8, 50
New York, 2, 118, 119, 120, 123, 124, 167, 182, 184
New York Academy of the Fine Arts, 7
New York painters, 167
New York Times, 129
Newman, Barnett, 119, 129, 131, 160, 161–162, 166–167, 168, 169; *Euclidean Abyss*, 161, fig. 85; *Onement I*,

161–162, 166, fig. 88; *Vir Heroicus Sublimis*, 166–167, fig. 95
Niagara Falls, 8, 55
Novak, Barbara, xi-xii, 200–201*n*6

Old Masters, 55
Old World, 2, 7, 11, 13
Ossoli, Margaret Fuller, 12

Paleolithic cave painters, 165
Paris, 17, 18, 20, 66, 131
Parrhasios, 54
Parsons Gallery, Betty, 165, 167
Peale, Charles Willson, 6, 7, 10, 54; portrait of William Pitt, 54, 190*n*13; *Staircase Group*, 54, fig. 38
Peale, Raphaelle, *Venus Rising from the Sea-A Deception*, 54, fig. 39
Peale, Titian, 54
Pelham, Henry, 47, portrait by Copley, 48–49, fig. 27
Philadelphia, 3, 7, 129
Picasso, 19, 68, 118, 120, 121; *Guernica*, 118
Pitt, William, portrait by Peale, 10, 190*n*13
Pliny the Elder, *Natural History*, 54
Pollock, Jackson, xxii, 127, 130–131, 132, 160, 164–166, 169, 170; *Number 1A, 1948*, 165, 168, fig. 93, color plate IV
Pop art, 185
Popular Front, 112
Post-Impressionism, 169
Poussin, 2

Van Dyck, 50
Van Gogh, 18

Walpole, Horace, 8
Washington, George, 6, 54
Weber, Max, 113–114, 129
West, Benjamin, 3, 4, 7, 48, 50, 52
Whitman, Walt, 20, 114; *Leaves of Grass*, 114
"Whitney Dissenters," 128; *see also* "The Ten"

Whittredge, Worthington, 11–12
Wood, Grant, 18
Work Progress Administration (WPA), 115, 116, 118, 123–124, 130, 169
World War I, 111
World War II, xxi, 1

Zeuxis, 54